IMAGES
of Rail

RAILROADS OF OMAHA
AND COUNCIL BLUFFS

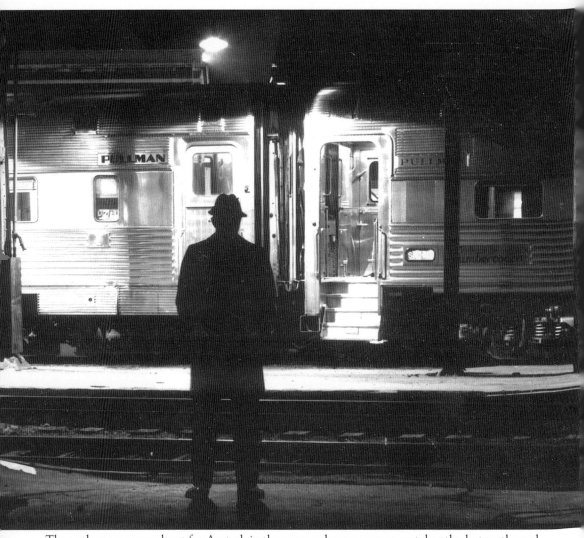

The author, as a consultant for Amtrak in the car purchase program, watches the last eastbound Burlington Denver Zephyr pause the night before Amtrak began operation, April 30, 1971. (Thomas O. Dutch photo.)

The cover illustration is the Gilbert Stanley Underwood-designed Omaha Union Station of 1931, now owned by the City of Omaha and operated by the Durham Western Heritage Society. (Durham Western Heritage Society photo, author's collection.)

IMAGES
of Rail

RAILROADS OF OMAHA
AND COUNCIL BLUFFS

William Kratville

ARCADIA

First Printed 2002.
Reprinted 2003.

Published by Arcadia Publishing,
an imprint of Tempus Publishing, Inc.
Charleston SC, Chicago, Portsmouth NH,
San Francisco

Printed in Great Britain.

Library of Congress Catalog Card Number: 2002111104

For all general information contact Arcadia Publishing at:
Telephone 843-853-2070
Fax 843-853-0044
E-Mail sales@arcadiapublishing.com

For customer service and orders:
Toll-Free 1-888-313-2665

Visit us on the internet at http://www.arcadiapublishing.com

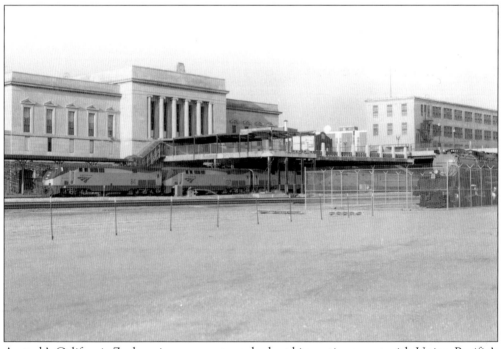

Amtrak's *California Zephyr* gives passengers a look at big motive power with Union Pacific's world's largest steam and diesel locomotives on display on the road's ex-Omaha Union Station grounds.

CONTENTS

Acknowledgments 6

Introduction 7

1. The Union Pacific 9

2. The Burlington 41

3. The North Western 59

4. The Missouri Pacific 75

5. The Rock Island 89

6. The Milwaukee 97

7. The Illinois Central 105

8. The Great Western 109

9. The Wabash 113

10. The Other Roads 117

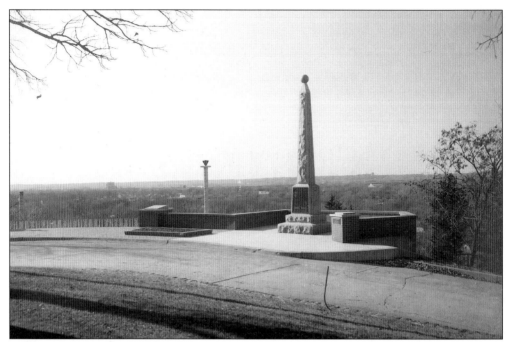

While searching for possible starting points for a transcontinental railroad, General Dodge and Abraham Lincoln looked west over the Missouri River valley from this location in Council Bluffs in 1859.

ACKNOWLEDGMENTS

This book is a compilation of photographs gathered from various individuals and collections in order to portray the railroads in the Omaha and Council Bluffs area. It is not a definitive history book, although the captions do furnish much information. The photos were selected to show the area's rail activity in the past, basically in the era most refer to as the "heyday" of railroading. The present operations are in place and available to those pursuing rail interests today.

Many of the photographs in this book are by the author or from the author's large collection compiled over the years. However, the assistance, both photographically and historically, of many individuals within the area has made the difference in the presentation within these pages. The author acknowledges the following for their complete help in this endeavor: Donald D. Snoddy, the Mike Connor Collection, Thomas O. Dutch, James Reisdorff, Vern Lenzen and the Archives of the Bostwick Collection, Durham Western Heritage Society, the Union Pacific Museum Collection, Lou Schmitz, Ray Lowry, the Henry Hamann Collection, the Charles Duckworth Collection, the James Martin Collection, the George Kieser Collection, and Jack A. Pfeifer. The author also acknowledges the great and open assistance of the Union Pacific Railroad's Public Relations and Operating Department officials, past and present, to provide photos for publications. Special thanks also to Ms. Catherine Kratville; without her computer assistance, this book would not have been possible.

INTRODUCTION

Railroading came to the Omaha, Nebraska and Council Bluffs, Iowa area when Abraham Lincoln met with General Grenville Dodge in the Iowa town in 1859 to discuss the best location for building a railroad west from the area. When the Pacific Railway Act was passed by Congress in 1862, the earlier meeting of Lincoln and Dodge became a prime point in Lincoln's 1863 endorsement of Council Bluffs as the eastern terminus of the transcontinental railroad.

Delayed by the Civil War, activity finally began in Omaha in December of 1863 with a ceremony on the west bank of the Missouri River, but actual construction did not begin until July, 1865, when the first rail was laid.

It was logical to start construction on the Nebraska side because all material had to be brought up the Missouri River by steamboat, as there were no railroads or bridges from the east. By 1867, the Chicago and North Western had reached the Bluffs, followed by the Rock Island in 1869, and the Kansas City, St. Joseph and Council Bluffs from the south in 1870. The area was becoming a rail center, but all transfers had to be accomplished by car ferries.

The completion of the Union Pacific in 1869 provided a reason for other railroads to build to Council Bluffs and Omaha. The Missouri Pacific came in from the south, while the Milwaukee, Illinois Central and Chicago Great Western approached from the east, and the Wabash came from the south on the Iowa side. The Omaha Road, owned by the Chicago and North Western, operated down from Sioux City. "Omaha's own" South Omaha Terminal Railway began as an inter-facility operation by the Union Stockyards Company of South Omaha. In fact, for most of history, the only railroad presidents headquartered in Omaha were those of the Union Pacific and the South Omaha Terminal Railway.

The importance of both cities to the railroad world is highlighted by the fact that, for years, Omaha was the nation's fourth largest rail center and Council Bluffs was the fifth. With the mergers of recent years, the number of roads has shrunk from a high of ten to six—Union Pacific, Burlington Northern-Santa Fe, Canadian National, Iowa Interstate, Council Bluffs Railway, and the Brandon Railroad. Regardless, there is still abundant railroad activity within the two cities. The Union Pacific alone operates over 70 trains through Omaha per day; and, while it does not own its own trackage in the area, Amtrak operates the daily California Zephyr through Omaha.

One
THE UNION PACIFIC

When you think Omaha, you think Union Pacific. The first railroad, the largest employer, Road of the Streamliners—the Union Pacific has been all of these. The big player on the Omaha-Council Bluffs scene has always been the Union Pacific. The UP ran more trains, is headquartered in Omaha, was the largest employer in the area for years, had the biggest payroll, and introduced the streamlined train and the McKeen motor car, forerunner to the Streamliners. The UP also was known for massive motive power such as Big Boys, turbines, and Centennial diesels. Its name is synonymous with railroad history.

The first rail of the transcontinental railroad was laid in 1865. By 1866 the road was operating westward on a limited basis.

After 1877, most of the operation of trains, except for the Omaha Shops, was actually out of Council Bluffs due to the lawsuit establishing the Bluffs as "milepost 0".

Due to the Omaha grade to Summit, the road maintained a helper pool, the only road to have an assigned district. The Omaha Road, Burlington, and North Western to the west all had grades but simply pulled yard locomotives from their assignments to help trains as needed.

The busiest time of the year for the UP was from August through December due to "green fruit" movements from the west, along with the annual local fall harvest traffic. Today, about 70 trains pass through Omaha in the UP's new "directional running" pattern. Most "hot" traffic uses the ex-C&NW Missouri Valley, Iowa to Fremont, Nebraska line.

The road is constructing a new Union Pacific Center headquarters to replace the 1912 structure. The old shop grounds are becoming the city's new convention center. The majestic Underwood design station is now the Durham Western Heritage Society museum. Omaha is changing but the Union Pacific still dominates the railroad scene!

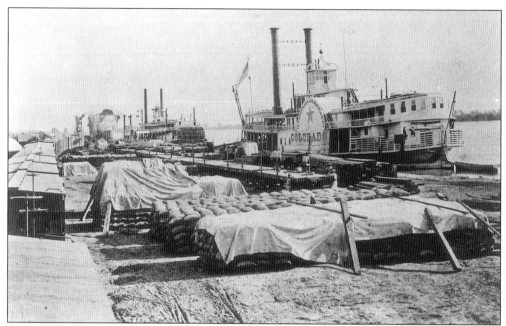

All material and equipment for the Union Pacific effort was brought up the Missouri River by paddle-wheel steamers until a bridge was opened in March, 1872. Before then, the docks near Davenport Street were busy locations for transferring goods and material for points west. (Union Pacific photo, author's collection.)

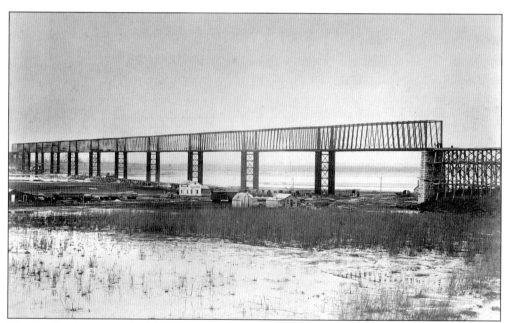

The first bridge across the Missouri opened in March, 1872, and was constructed of cast iron. Its method of placing the piers was a "first" in bridge construction. Tubular iron piers were erected and filled with masonry. Not long after completion, the eastern span was destroyed by a high wind. A second bridge was opened in 1887, followed by the present structure in 1916. (Union Pacific photo, author's collection.)

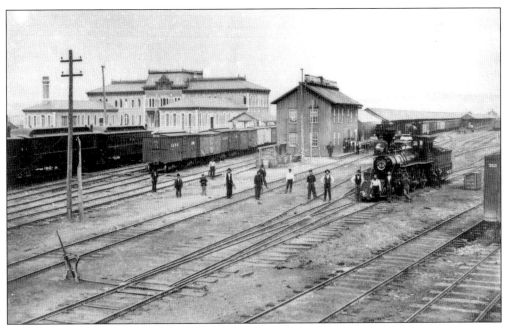

Pictured is the new Council Bluffs Transfer in the 1877 era. Loco 53 was famous for being wrecked in the Plum Creek Massacre of August, 1867. (Union Pacific photo, author's collection.)

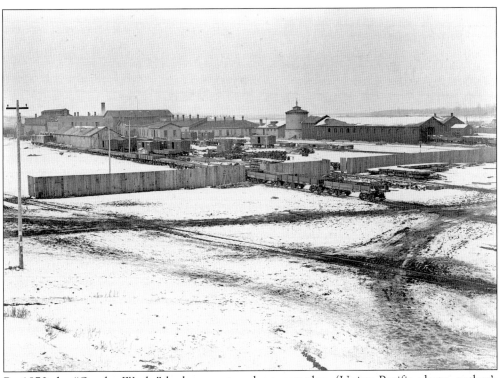

By 1870 the "Omaha Works" had grown to a large complex. (Union Pacific photo, author's collection.)

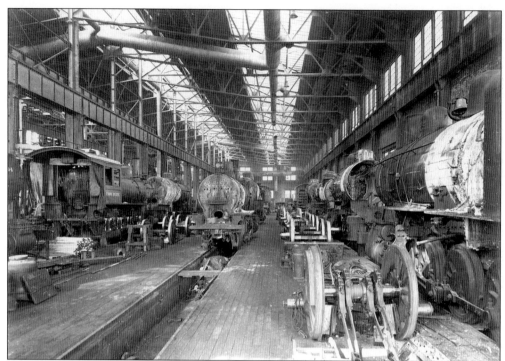

Under E.H. Harriman's rebuilding of the road came a larger and more modern facility in 1907. By 1910, the new machine shop was the scene of great activity, including work on older locomotives still equipped with the older Stephenson valve gear (foreground). (Union Pacific photo, author's collection.)

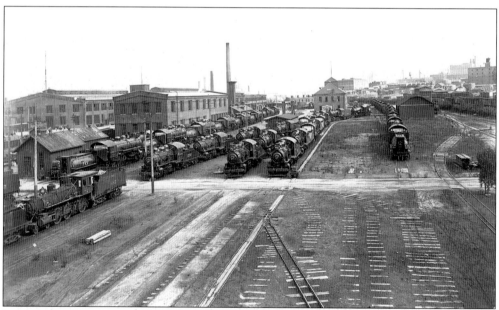

In 1913, new locomotive orders were stacking up as new power was "set up" by the shop before being placed in service. Each road locomotive was tested at least once to Gilmore and back by "engine tamers" who noted any defects. (Union Pacific photo, author's collection.)

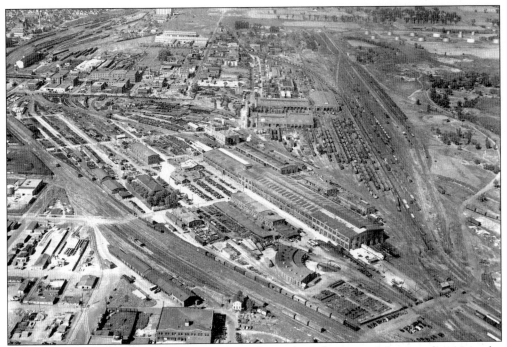

An aerial view of Omaha Shop in about 1940 shows the full extent of the complex. Note the City of Denver type unit just outside the main bay. The general office was surrounded by trees and featured some glazed Pullman windows until a new building was erected in the 1960s. (Union Pacific photo, author's collection.)

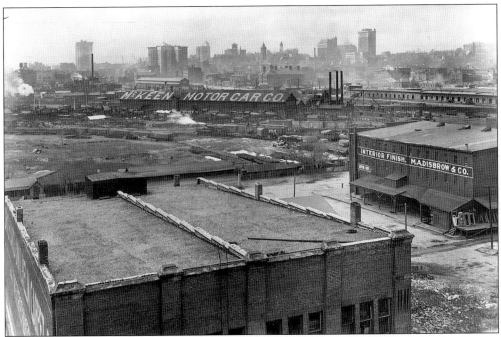

The famous McKeen Motor Car Company operated from a leased building within the Omaha Shop complex, pictured here May 1, 1919. (Bostwick photo, author's collection.)

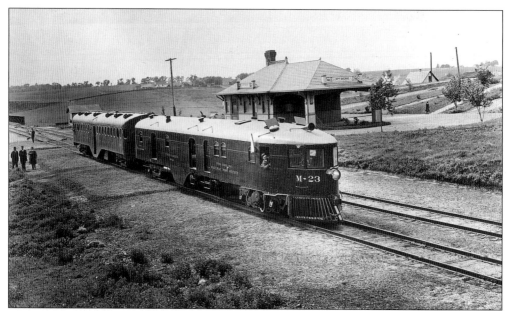

A Thirty-second Avenue depot was built to serve cattle industry men who lived nearby in the fashionable Woolworth Avenue area, where President Gerald Ford was later born. McKeen posed his new heavy motor and trailer car for photos in early 1910. (Bostwick photo, author's collection.)

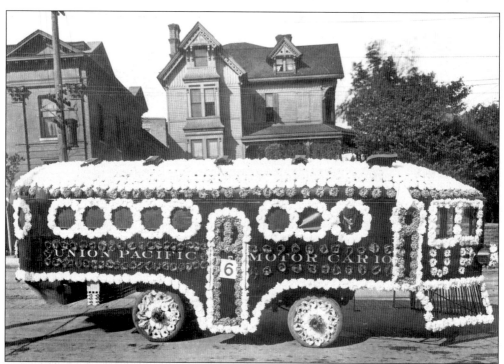

The none-too-shy McKeen made certain his company was always involved in Omaha social and civic events. This Ak-Sar-Ben Parade float, built in the McKeen shop, was featured in the 1911 parade and was about the only float that did not utilize the trolley wires for lighting.

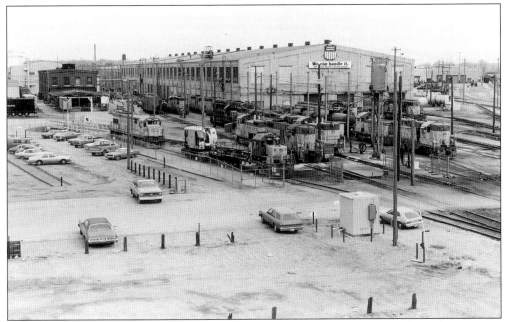

Omaha Shop, Omaha's largest employer in the postwar era, was, by 1983, shopping diesels but had the Big Boy 4023 on display on the grounds. The entire shop area is now the site of the new Omaha Convention Center. (Thomas O. Dutch photo.)

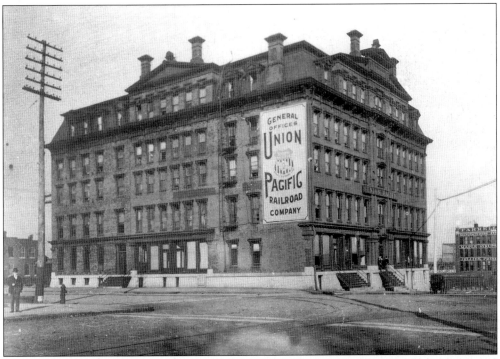

The first Omaha headquarters were in the former territorial capitol building on Ninth and Douglas. They were moved in 1869 to the ex-Herndon Hotel building at Ninth and Farnham (correct for the era) and later enlarged. (Union Pacific photo, author's collection.)

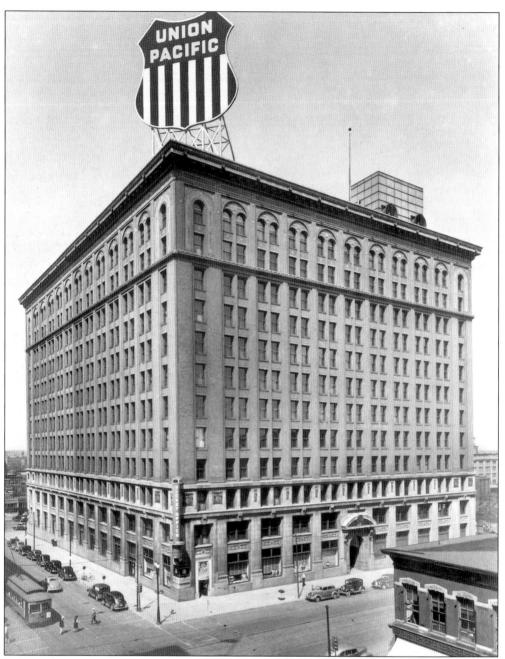

The present headquarters building was opened in 1912. In 1930, an addition was added on the north side (note differences in brick shades). In the late 1930s, a huge electric sign was added to the southwest corner which remained a landmark until the 1950s. Subsequent additions were made in the 1960s on the east end, and a separate "IBM" unit was added on the Capitol Street side in 1955. (Union Pacific photo, author's collection.)

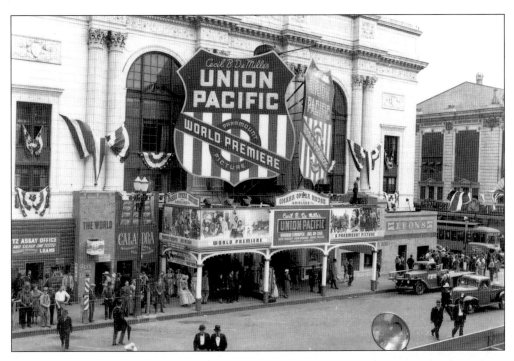

Through friendship with local ad man Morris E. Jacobs, in 1939 the railroad influenced Paramount Pictures to make a film depicting construction of the line. The Golden Spike Days celebration turned out to be one of the most remembered events in city history, and was repeated again on a smaller scale in 1940. The movie premiere was held at the Omaha Theatre with all the film's stars attending. The parade featured an Omaha Shop-built "mini-train" with employees flanking it as it wound through downtown. (Union Pacific photos, author's collection.)

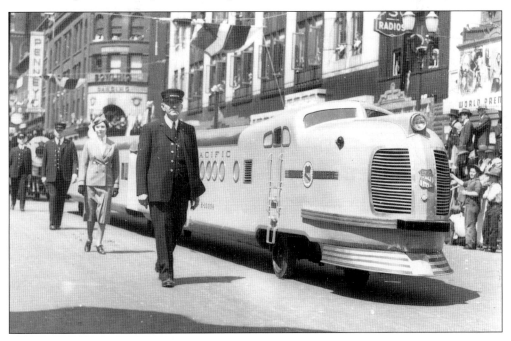

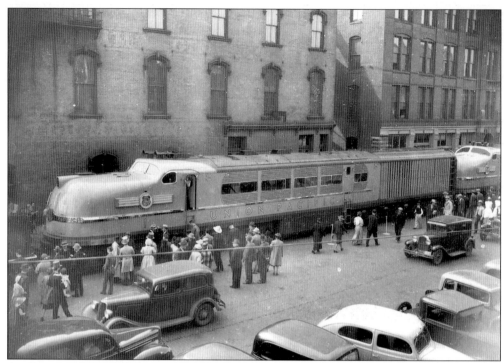

At the time of the film, the road had just joined with General Electric to construct two steam turbine locomotives, and these were displayed during the event, drawing much attention. (Union Pacific Historical Collection.)

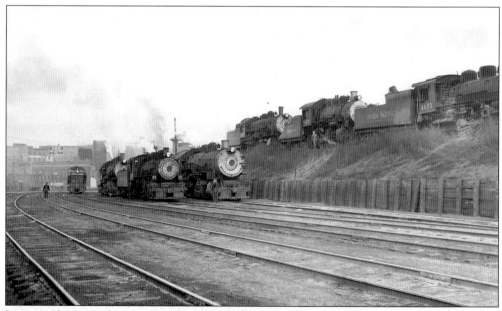

In steam days, Omaha-area switching locomotives were based at Fourteenth Street. This 1940 view shows the first diesel switcher, 0-6-0s, 2-8-2s, and a USRA 0-6-0 as switch power for the "Jobbers Canyon" and other industry moves. At far left is the Fourteenth Street crossing watchman's shack.

This photo looks south from the old Douglas Street highway bridge to the Burlington Route freight house and docks and the large Omaha and Council Bluffs Street Railway power house. (Mike Connor Collection.)

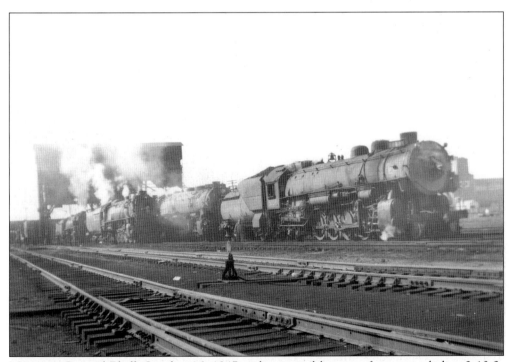

Morning, Council Bluffs October 16, 1947 with a typical line-up of power including 2-10-2s and 4-12-2s called for westbounds and 4-8-4s for the morning varnish fleet out of Omaha Union Station.

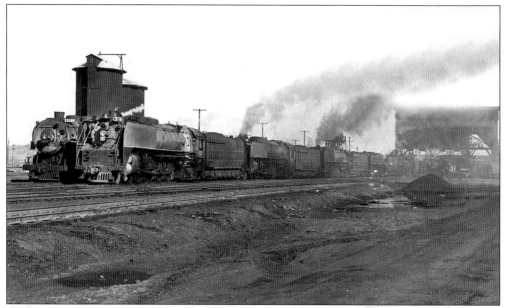

During the flood scare of April, 1952, all power was moved dead to the fill leading to the bridge or kept under steam with engine watchmen ready to move the power to higher ground if the dike broke. Luckily it held. The 800s were all eastbounds from the night before, and were quickly turned and spotted for the hostlers if needed.

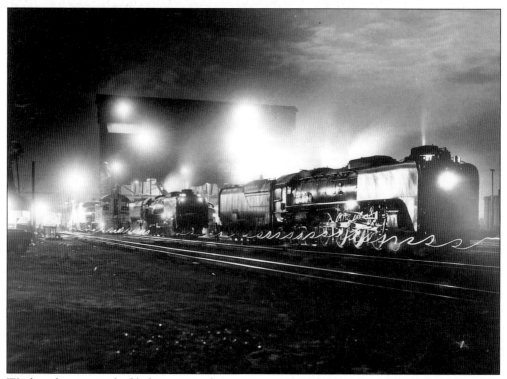

Workers leave a trail of light tracing their moves at the Bluffs in September, 1955. Twenty-seven's power is ready to head for the depot, with 85's 800 waiting its turn.

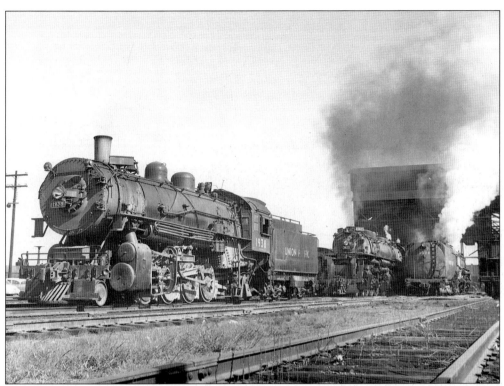

The coal chute in the Bluffs held 650 tons of coal. In July, 1956, a 3800 is on the inspection track, and a light Challenger is on the outbound with helper 1938 awaiting a turn to Foxley.

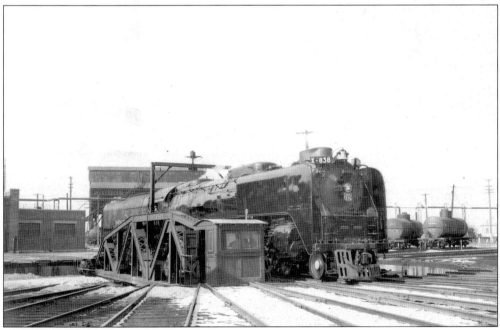

The last steam locomotive released by Omaha Shop, the 838, spins on the Bluffs table before being "stored serviceable" in 1959.

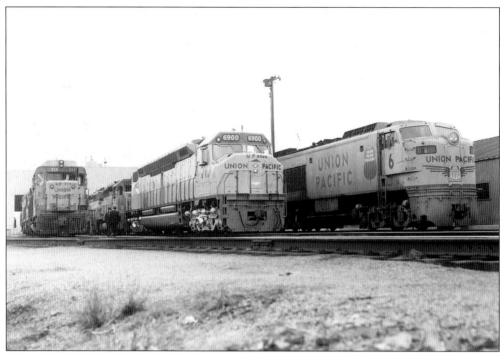

New Centennial type 6900, the world's most powerful diesel at the time, receives a last-minute check by officials at the diesel house before going out on its first run. The 6900 is flanked by GP 719 and turbine 6, May 2, 1969.

The UP borrowed power from the Santa Fe and Milwaukee during the fall of 1952 power shortage. An IC 2-8-2 rolls out of the yard past Tower A in the Bluffs.

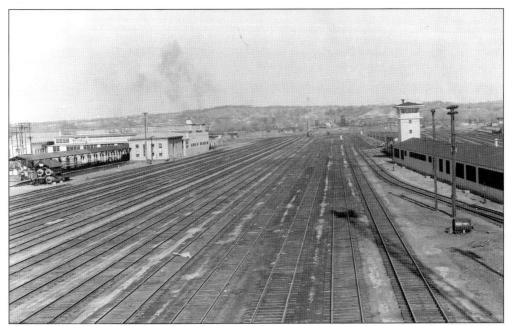

A very rare occasion—the Bluffs yard and Transfer empty! All equipment was evacuated as a flood precaution, April, 1952.

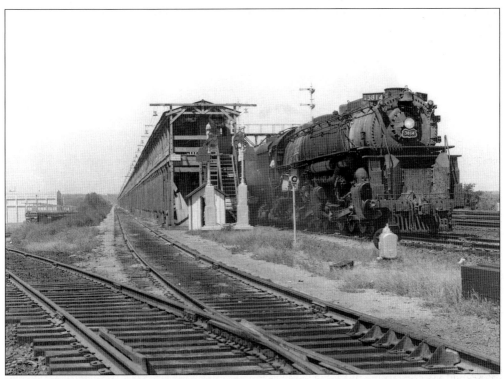

The Council Bluffs Pacific Fruit Express ice house and dock, just east of the bridge, were busy facilities, particularly in summer and fall. The 3814 has just brought in a "green fruit" train from Grand Island and is about to release for the roundhouse, September, 1955.

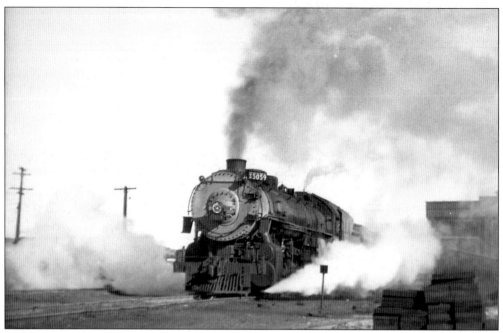

The 2-10-2 5029 clears its cylinder cocks and departs the Bluffs yard in a cloud of steam and smoke, September 29, 1946.

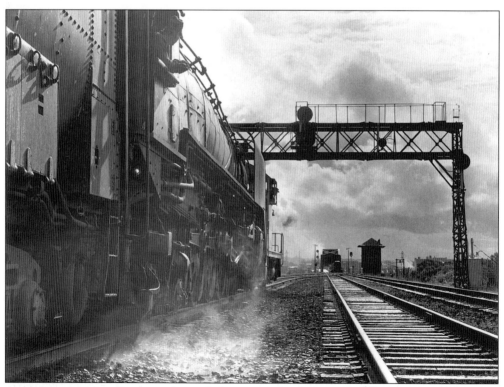

A westbound with a diesel switcher as helper, waits for the green light to move onto the main past "little tower" B at the east end of the bridge, 1952. (Thomas O. Dutch photo.)

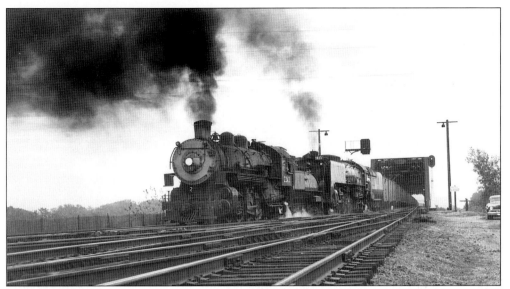

A westbound empty PFE train with 4-8-4 road power and a customary 2-8-2 helper comes off the Missouri River Bridge and begins climbing the 1.55 percent grade to Summit. (Thomas O. Dutch photo.)

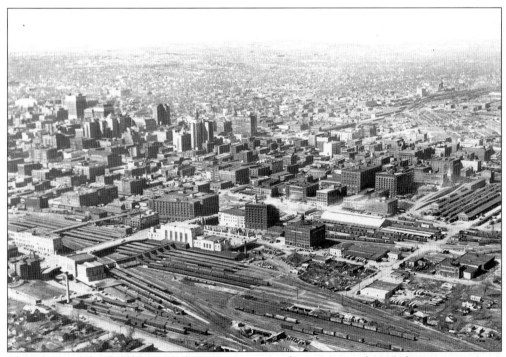

This photo of the Burlington and Union Stations taken in June of 1947 shows proximity to downtown areas. The UP freight house is now the Harriman Dispatch Center. The Q complex contained a small passenger yard, and the UP passenger storage was in Council Bluffs. The UP Seventh Street yard is adjacent to the depot. The poles of the Nebraska Power Company electric line follow Seventh Street under the tracks to Jones Street and then east to the power plant. (John Savage photo, Durham Western Heritage Collection.)

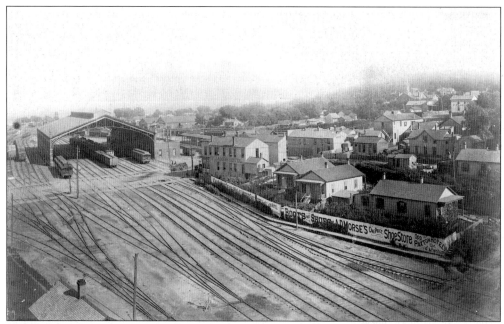

The famous 1872-built "Cowshed" was the UP depot. The busy street crossings were protected by watchmen until the Tenth Street viaduct was completed. Note that homes and buildings were right next to the tracks! In the background is the Burlington Railroad depot area. The arch beams for the cowshed were later used as the roof support for the Harriman-era freight house and are still in use in the converted freight house which is now the Harriman Dispatch Center. (Durham Western Heritage Collection.)

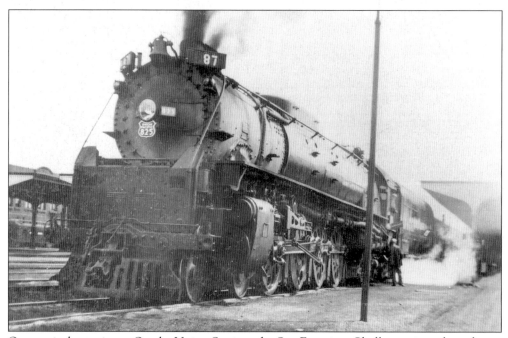

On a typical morning at Omaha Union Station, the San Francisco Challenger is ready to depart behind one of the road's own "Jabelmann" designed 4-8-4s, April 15, 1946.

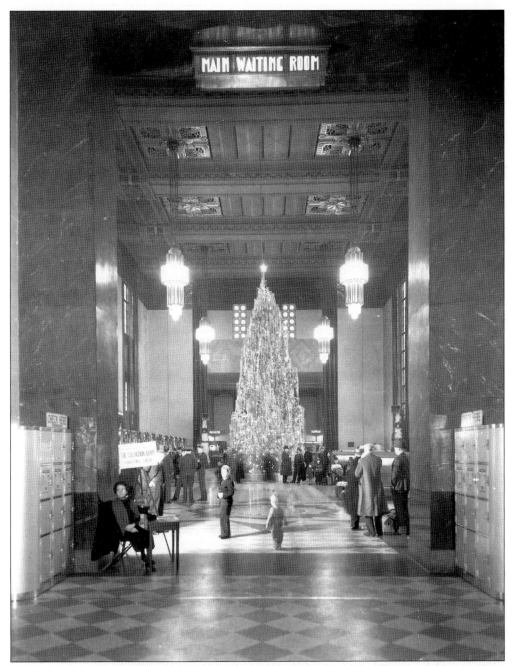

From the days of the 1899 depot and continuing in the 1931 building, now the Durham Western Society Museum, the Christmas tree was a tradition and highlight of the season for Omahans. This tree was the 1931 version. (Union Pacific photo, author's collection.)

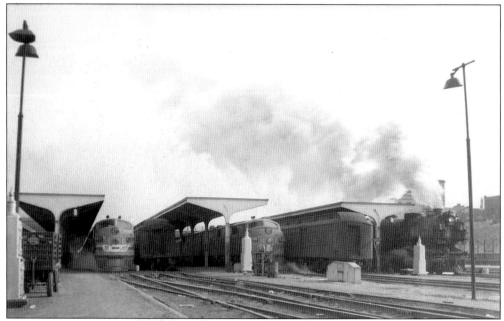

The great blizzard of early 1949 caused unique operating situations. The City of Los Angeles and the City of San Francisco were held at Omaha. At right, the monstrous 4-12-2 freight loco 9052 pulls out with a westbound passenger train. Freight power had to be used because no passenger power was yet able to get in from the west.

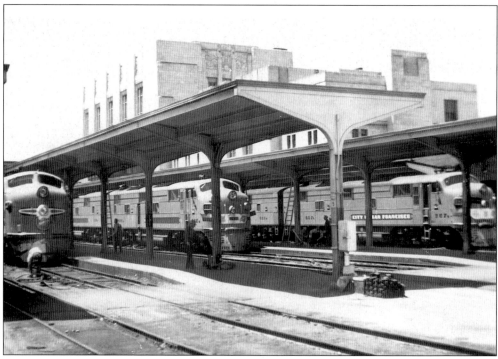

Floods east of Omaha on the C&NW caused Chicago-bound Streamliners City of Portland, City of Los Angeles, and City of San Francisco to be held at Omaha for several days. June 22, 1947.

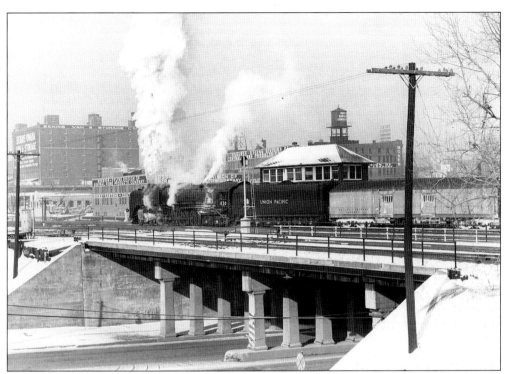

The UP-designed 4-8-4 830 begins to accelerate its train out of Omaha beside tower B, December, 1952. (Thomas O. Dutch photo.)

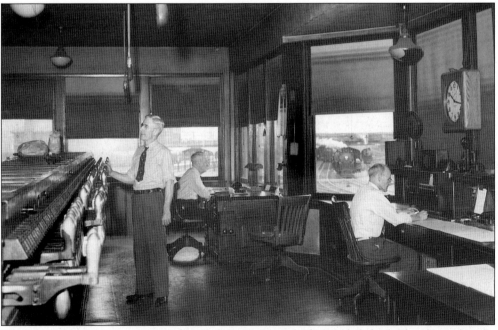

The west end of the depot was controlled by Tower B and included the bridge dispatcher. In 1944, train 9, one of the morning "fleet", and a 4-8-2 powered train are ready for the highball from the tower. (Union Pacific photo, author's collection.)

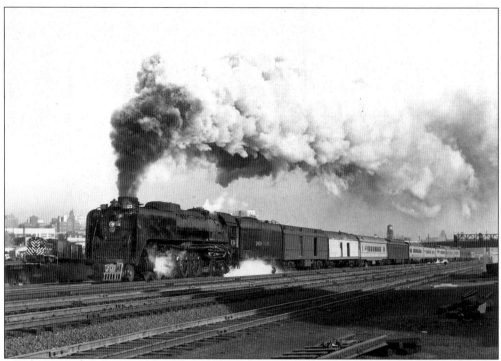

One of the last series 4-8-4s gets a wheel on the Gold Coast Limited past tower C, Omaha, in January, 1954.

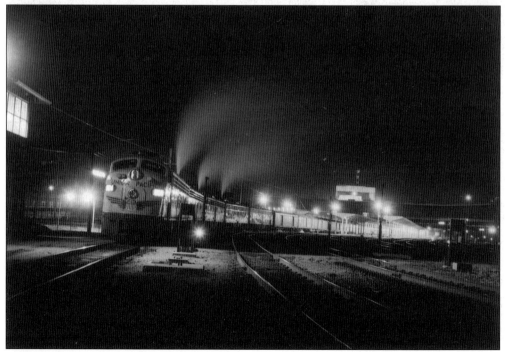

The City of Los Angeles, train 103, is ready to depart Omaha Union Station for the last time, April 30, 1971.

The last eastbound COLA, train 104, is ready to go out over the Milwaukee in the early morning of April 2, 1971.

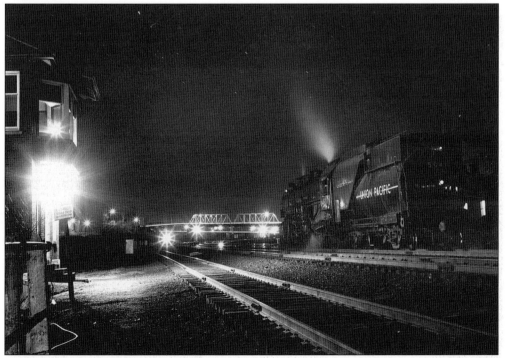

Stuck on a signal, 2-10-2 5041 awaits a "lunar" to drift on back from Tower C to the Bluffs after helping a westbound to Foxley. 1957.

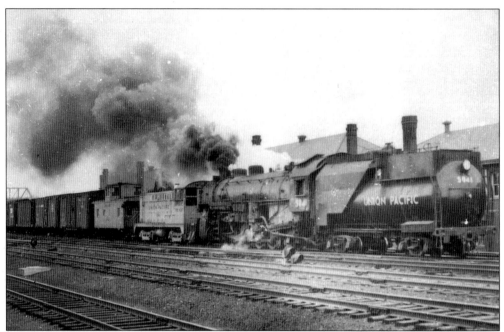

Often westbounds would stall on the grade and any available power was sent to the rescue. In 1957, when the initial assistance of a nearby Baldwin switcher could not start the train, the 5041 was snagged from an eastbound move to the Bluffs, crossed over to track one, and also put behind the train to finally get it moving. (Harold Ranks photo, author's collection.)

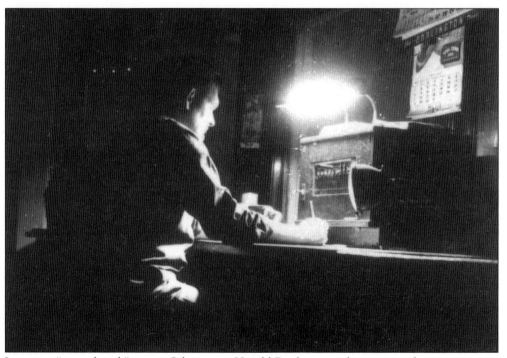

Late into "second trick", tower C leverman Harold Ranks notes the passing of a movement in the daily train movement book, 1957.

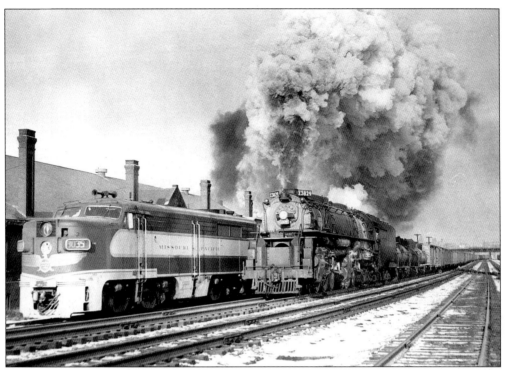

Tower C activity included the depot moves of the Missouri Pacific. An Alco PA type on the afternoon Sunflower holds on the track up from the lower yard, while a UP train hauled by a 3800-class Challenger pounds by with a westbound in January, 1956.

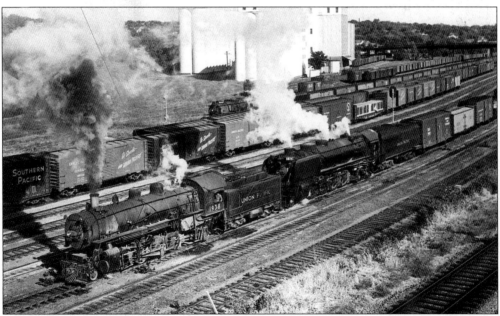

The fall rush of September, 1956, created congested traffic at Summit this day. Helper 1938 and a road 4-8-4 try to start their train without avail. In the background is another westbound empty PFE stalled just before the tower, awaiting helper assistance.

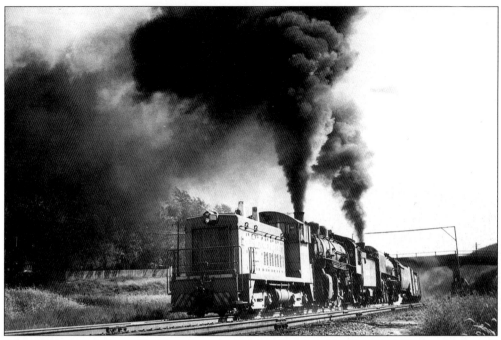

After getting a switcher added "on the point," the stalled train finally gets rolling under the old Dahlman Avenue overpass.

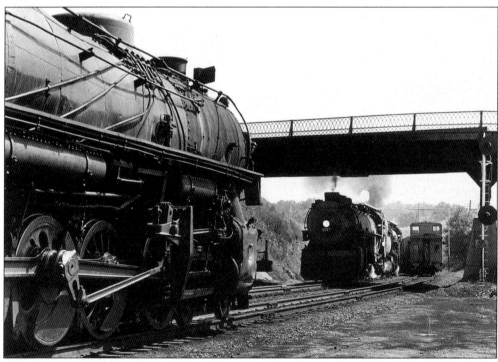

This was not an uncommon scene at Summit. An eastbound 4-12-2 holds behind another eastbound, while a westbound crawls around the curve behind a 2-10-2 helper and a road locomotive. (Thomas O. Dutch photo.)

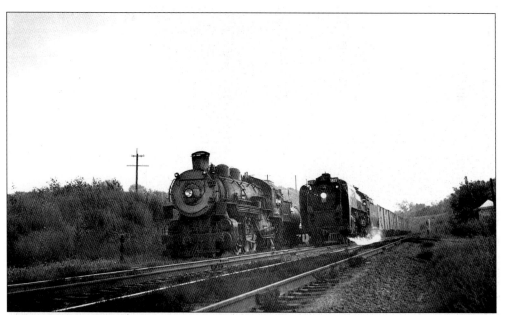

Helpers were cut off at Foxley, about a mile west of the top of the grade. Helper 2242 has backed into the clear and the 833 begins to accelerate its train in 1956.

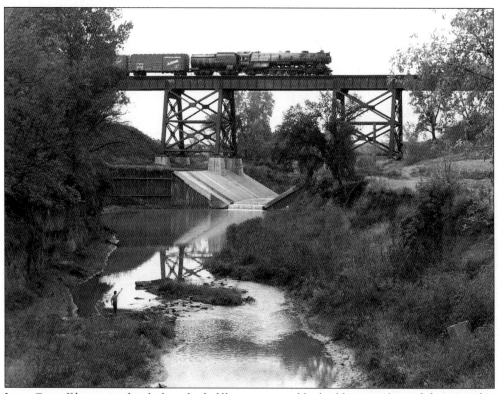

Lane Cut-off has several mile-long high fills, constructed by building trestles and dumping dirt to form the berm. The trestlework is still in the fills. An eastbound behind a 4-12-2 crosses Papio Creek in October, 1954. (Thomas O. Dutch photo.)

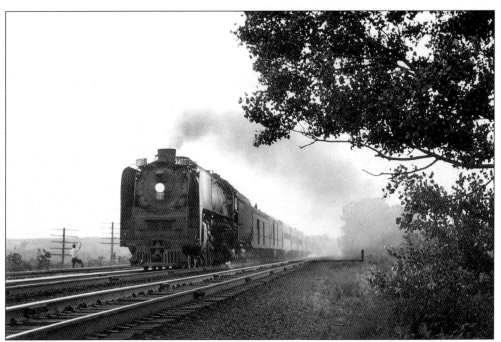

This is a typical evening scene on Lane Cut-off. The eastbound Gold Coast races through a July evening haze in 1953. The cottonwood trees were all removed in the 1960s.

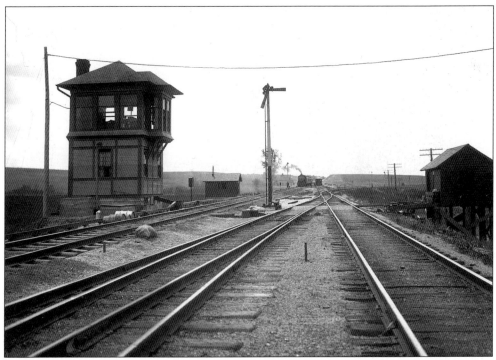

The west end of the Cut-off is Lane, protected by a signal tower until the late 1940s. This scene from around 1908 shows the recently constructed tower, train order signals, and a westbound passenger and eastbound McKeen car. (Bostwick photo, author's collection.)

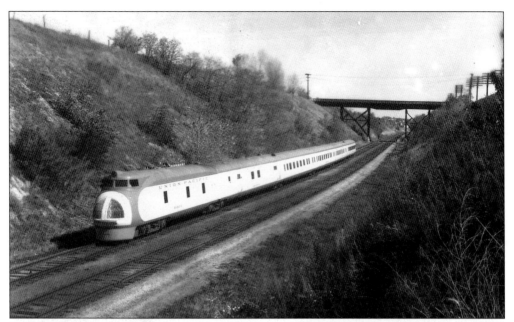

The world's first streamlined train was built by the Union Pacific in early 1934. By October 1934, a second train, the M-10001, was placed in service and posed in "Mud Cut" on south Forty-second Street for publicity photos. The train later went on to set a road speed record of 120 mph in western Nebraska, and also a never-broken record of the shortest time between Los Angeles and New York on a special speed run. (Union Pacific photo, author's collection.)

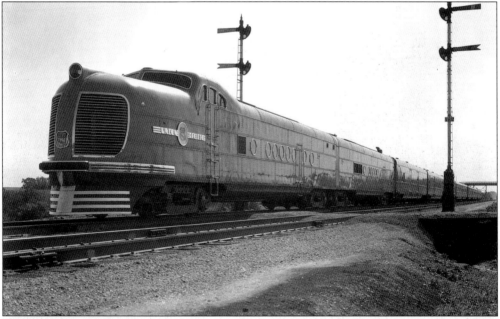

By the summer of 1936, the Streamliner fleet had grown to include what has become one of the best-remembered streamlined train designs of all time—the City of Denver "automotive"-style locomotives. Even as late as the 1980s, Amtrak gave some thought to planning new power along these stylish lines. (Durham Western Heritage Collection.)

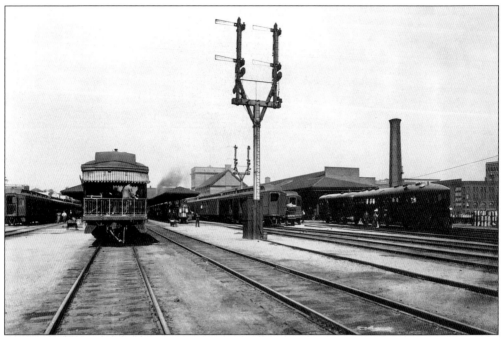

This photo looks west from the east end of the 1899 depot complex. The McKeen cars are being used in a McKeen Company photo shoot. The observation car with the old Howard brass gate and awning is on a westbound train. The semaphores were replaced by modern dwarf units in the 1931 design. (Bostwick photo, author's collection.)

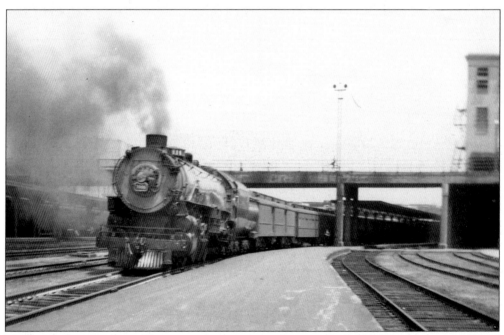

Flooding led to the City of Denver operating as a stub consist behind UP mountain type 7006 on June 24, 1947. The train operated to Grand Island over the Burlington, then back on the UP to Denver.

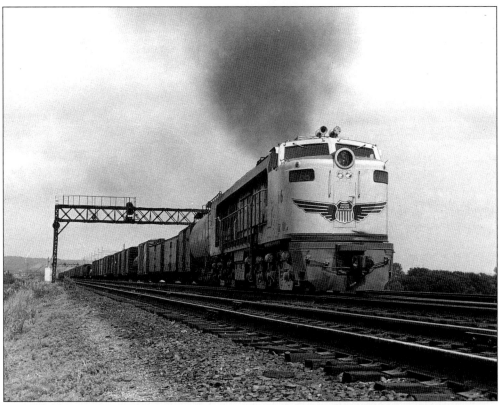

A turbine crawls over to track one at tower B, Council Bluffs, in 1958. (Thomas O. Dutch photo.)

Locos from several roads often released from their trains and had to hold west of the depot before backing across to their Bluffs yards. Pictured here are a C&NW H off the Corn King, Milwaukee S-3 from the Arrow, and a UP 800 ready to back to its train in April, 1946.

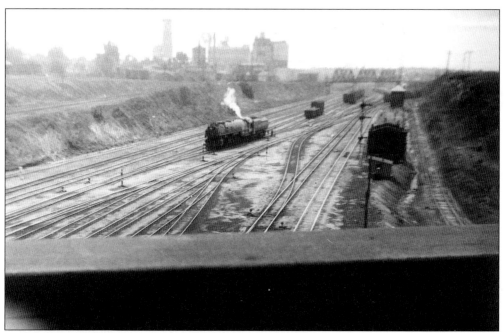

This picture of Summit yard was taken in August of 1943. The 9054 has just set off cars and prepares to back to its train still on the main behind the tower.

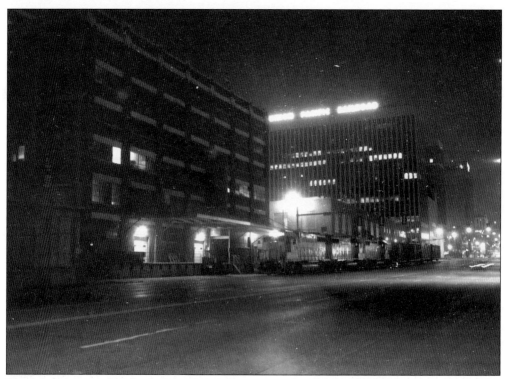

The last downtown Omaha industrial switching was to the Omaha World-Herald, and was done thrice weekly at night to reduce auto interference. In 1998, a cut is spotted at the Herald's dock.

Two

THE BURLINGTON

The Council Bluffs and St. Joseph Railway built south out of the Bluffs in 1867, and later became the Kansas City, St. Joseph and Council Bluffs Railroad before being absorbed first by the Burlington and Missouri River and finally the Burlington. This line was the main line as far as Pacific Junction, Iowa, about 16 miles south of the Bluffs. From there the line runs south to St. Joseph and Kansas City, and was the route of the first "Q" streamliner, the Silver Streak Zephyr, in 1934. The portion south of the Bluffs to "Pjunct," as it is often called on the railroad, was abandoned in the 1970s but recently re-activated due to the building of a large corn processing plant on the line.

The Burlington reached Omaha from the west on what was then the Omaha and Southwestern in 1869. Lincoln, Nebraska has always been the hub of Burlington activity in Nebraska, including the shops at Havelock which even constructed steam locomotives in B&MR days. Omaha has always been, in effect, on a branch line. But all passenger trains used the Omaha line because the city was the most important traffic point in the state.

Freight-wise, the Omaha line was used for interline movements through Omaha, and today serves as a relief route when the river line east from Ashland to Pacific Junction, Iowa is crowded. Gibson Yard, with its expanded inter-modal facilities, is still the major yard. Amtrak also uses the Omaha route.

Motive power ranged from Havelock-built 4-6-0s to the handsome Hudson and Northern types on heavy passenger and freight trains, but freight was generally behind the drawbar of a Mike. Mountain types were also used in the 1920–1945 era on heavy passenger runs. With much industry switching in Omaha and the Bluffs, 0-6-0s were in abundance. South Omaha was important enough to maintain a small roundhouse at the east end of the yard which basically handled packing house and cattle traffic. It was removed by 1950.

Overall, the Burlington Route was probably better known locally for passenger traffic than the Union Pacific because the "Q" had so many trains going to so many places, particularly local destinations such as Kansas City. The Burlington also operated many special trains for organizations and occasions such as preview runs of new Zephyrs.

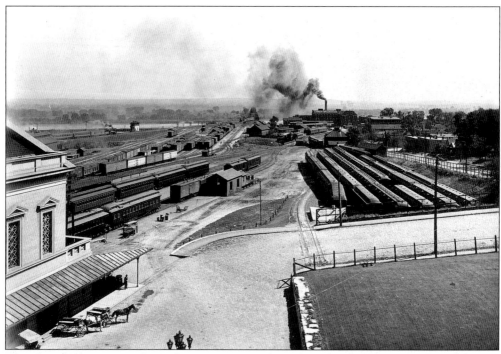

This photo looks east past the Burlington station and coach yard to the UP Bridge, September 16, 1909. The old UP depot tower A is in the left distance. (Bostwick photo, author's collection.)

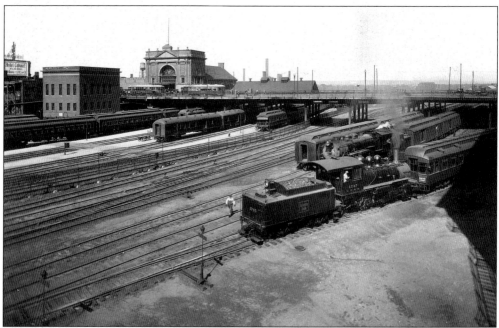

This picture captures activity on the afternoon of June 22, 1927. Burlington switcher 1715, coupled to an almost new solarium observation, is working the eastbound Overland Express. The westbound Express waits on an adjacent track to head west behind a big Pacific type. (Bostwick photo, author's collection.)

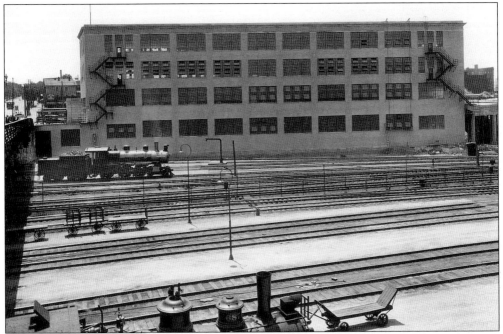

A Burlington ten-wheeler and a Wabash loco simmer against a backdrop of the recently completed Burlington Station Post Office building on June 28, 1926. The Q water standpipe was for through passenger power. (Bostwick photo, author's collection.)

On July 19, 1933, the eastbound Ak-Sar-Ben's Pacific exploded just as it entered the station. The loco was towed to Gibson Yard the next day for the investigation. (Bostwick photo, author's collection.)

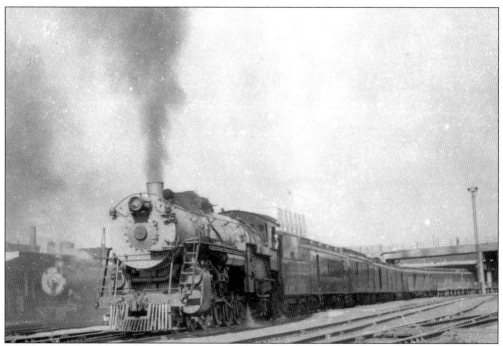

The Overland Express, behind a Mountain type, rolls out of Omaha in the 1930s. In the distance is the Union Pacific's famous Columbine, also behind a 4-8-2 headed for Denver. (Rail Photo Service, author's collection.)

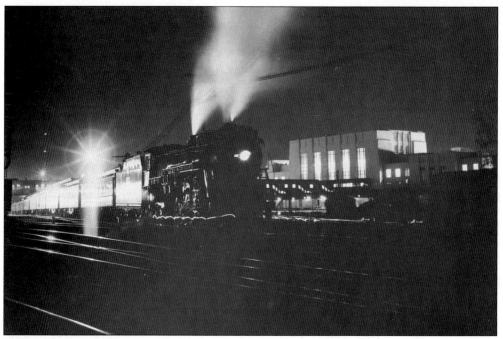

With a brightly-lit Omaha Union Station as a backdrop, Hudson type 4002 arrives from Lincoln with a Nebraska football special on November 2, 1956. It waits for passengers to detrain before heading back to the capital city via Louisville with the deadhead equipment.

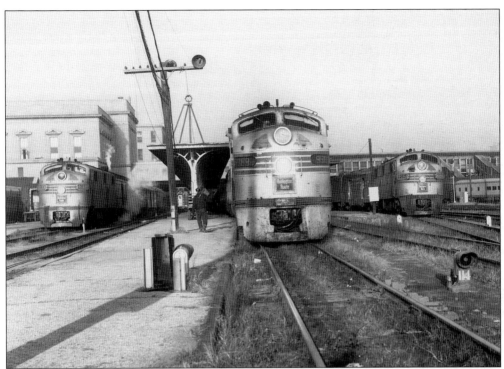

Early morning at Burlington Station was a busy time. In a picture taken on an October 1966 morning, the Kansas City-bound Silver Streak Zephyr is pictured on track one (left), the rear of the inbound Ak-Sar-Ben from Chicago is on two, the eastbound California Zephyr is on three, and 42 from Alliance is on track five.

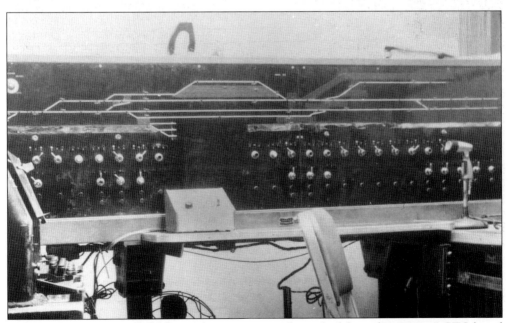

The Burlington Station complex, in later years, was dispatched from this "annex" CTC board in the depot and operated by the "DA".

An unglamorous use of Burlington's big steam power was spotting the 5627 for several months in 1959 while new heating boilers were installed in the boiler house.

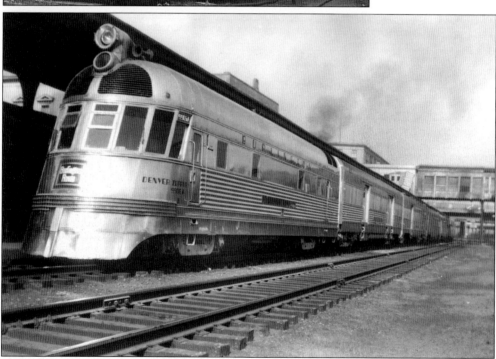

The Silver Streak Zephyr, behind ex-Denver Zephyr unit 9906-A, makes the Omaha stop before heading to Kansas City, May 26, 1948.

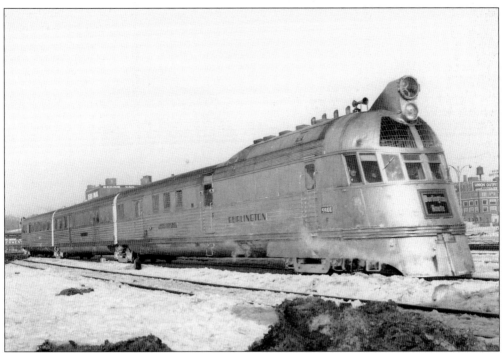

On March 20, 1960, the original Silver Streak, 9900, came into Omaha depot on its last run, on its way to the Museum of Science and Industry in Chicago for display.

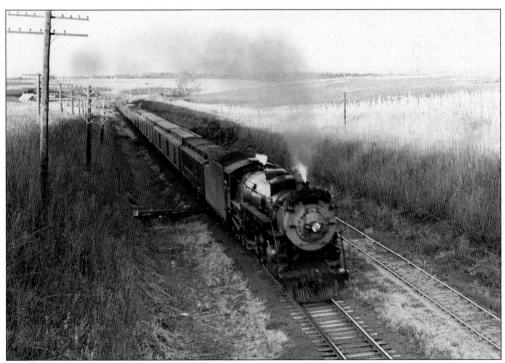

Around 1940, the westbound Overland Express tackles the grade out of Ralston behind a Hudson type, paralleling the MP for a short distance.

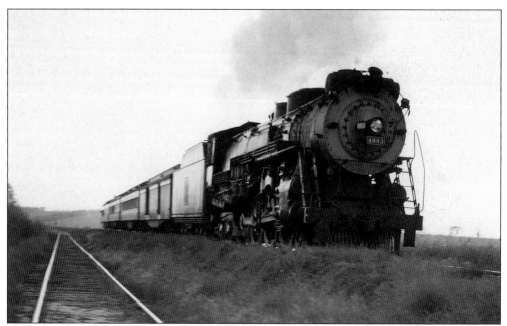

The banner train of the Q's Lincoln, Omaha to Chicago overnight service was the famous Ak-Sar-Ben, named for the popular civic organization in the state. In 1940, behind one of the road's handsome Hudsons, the "AK" nears Omaha just west of Ralston. The track at left is the Missouri Pacific branch to Weeping Water, Nebraska. (Barnhart photo, author's collection.)

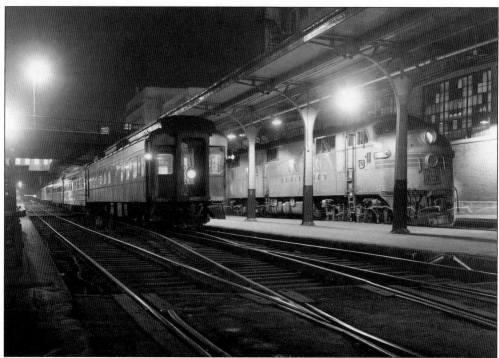

The last night of heavyweight lounge car operation on the Ak-Sar-Ben was April 13, 1966. Car 308 carries the markers. At right is the Alliance-bound train 43, due to depart at 11:45.

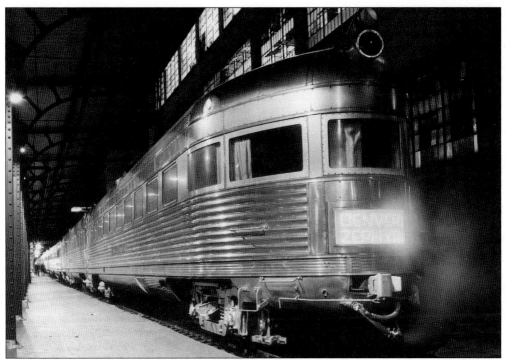

The last run of the eastbound 1936 Denver Zephyr equipment was as the second section of the first eastbound run of the new "DZ" in October, 1956.

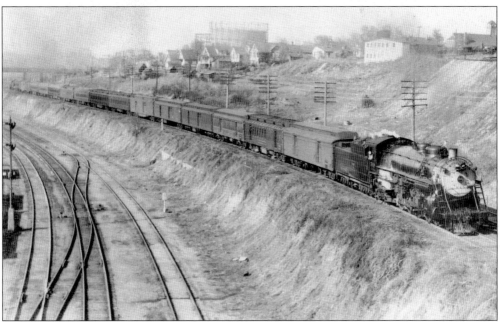

In the 1930s and 1940s, when the depot switcher was finished working the westbound Overland Express, it pushed the train up the grade to Vinton Street, then spent the rest of its shift switching industries including a large grain elevator operation. The 7018 was handling number 3 on July 2, 1937. The 0-6-0 580 is pushing at the rear. (Corbin photo, author's collection.)

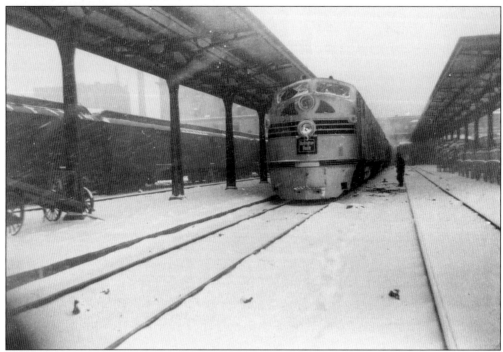

A Christmas Eve blizzard in 1945 surrounds the eastbound Ak-Sar-Ben Zephyr, a forerunner to the Nebraska Zephyr.

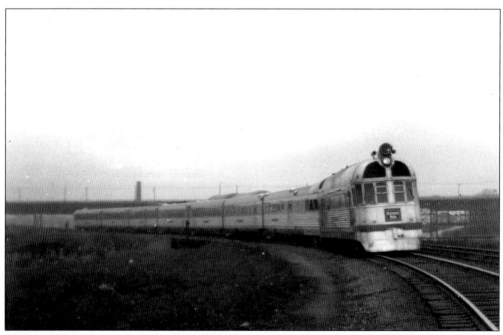

The new Nebraska Zephyr (formerly Twin Cities Zephyr) comes into Omaha on its first run, November 16, 1947.

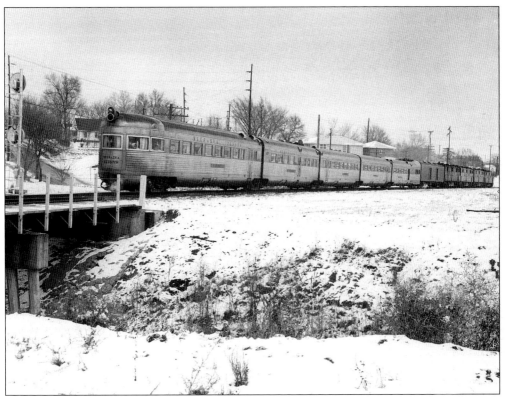

The Nebraska Zephyr, with its famous ex-Twin Cities Zephyr equipment, glides through South Omaha near Thirty-sixth Street on December 27, 1967. (Thomas O. Dutch photo.)

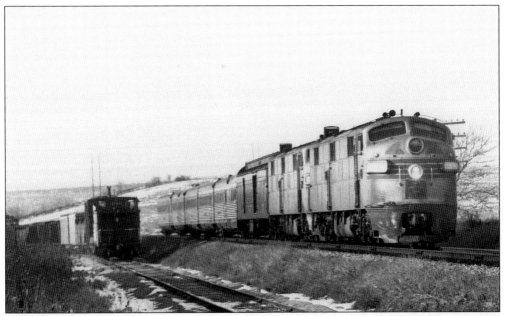

The eastbound Nebraska Zephyr ran alongside the MP's Weeping Water line just west of Ralston; often the daily "sand train" (local freight) and number 12 passed at this location.

The Burlington's wye at South Omaha was also used by the Auto-Liner Corporation shop to turn cars headed east on Amtrak's number 6. To save work in June, 1973, the BN loco simply dragged the South Omaha Terminal loco (including its crew) and car Silver Tower around the wye. The Stockyards Exchange Building is on the horizon.

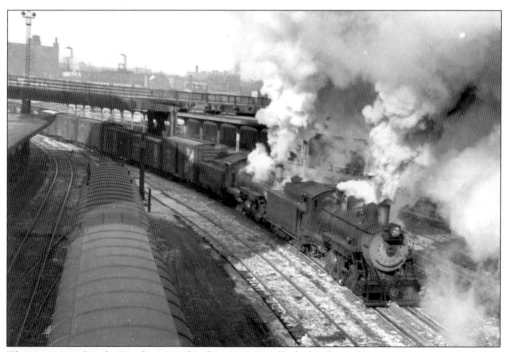

The morning South Omaha transfer drag was usually helped up the Omaha grade by 0-6-0s which cut off at Vinton and worked industries. This photo was taken December 24, 1949.

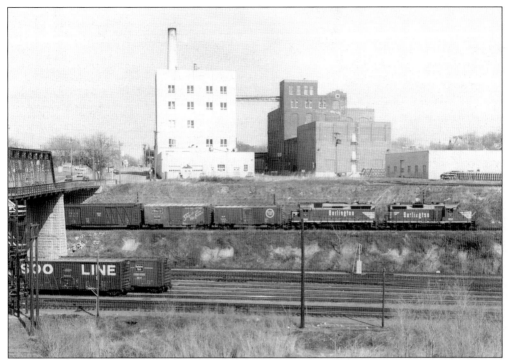

A pair of Q GP type locos crest the Omaha grade at Vinton Street. Behind the train is the Falstaff Brewery, a good customer, and below is the UP's Summit Yard. One night in 1936, an auto plunged off the viaduct and landed on the UP just as the City of Denver approached.

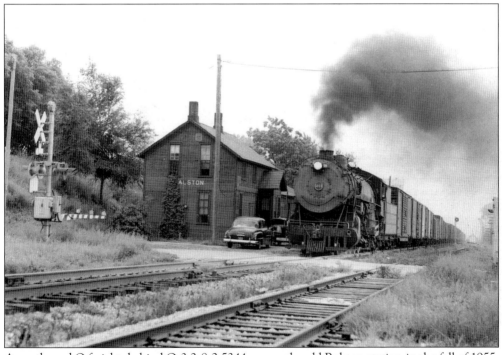

A westbound Q freight, behind O-3 2-8-2 5344, passes the old Ralston station in the fall of 1955.

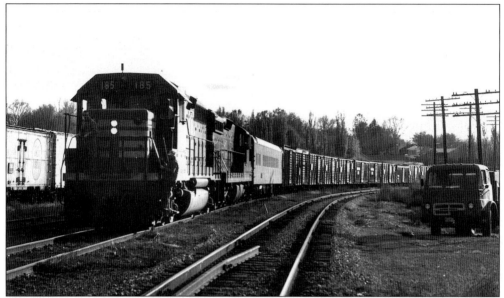

Fall stock trains were traditional on all roads into Omaha from the west. In this picture, a Burlington Northern stock extra from Wyoming comes to a stop at South Omaha, November 10, 1969, before the power is cut off and the train is handed over to the South Omaha Terminal Railway for unloading in the Omaha stockyards. The ex-C&NW coach behind the power is for the riders accompanying the cattle.

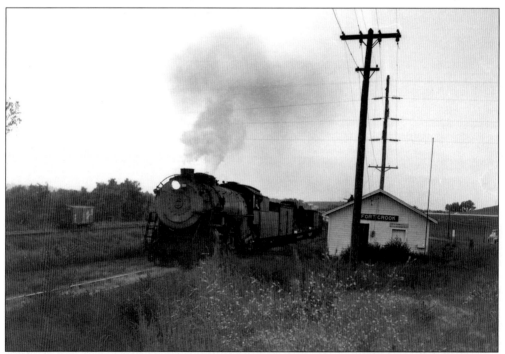

The evening "meat run" of the Burlington passes the depot at Fort Crook, Nebraska, named for the famous General who was commander of the "Valley of the Platte" army operations in the 1878–1880s era.

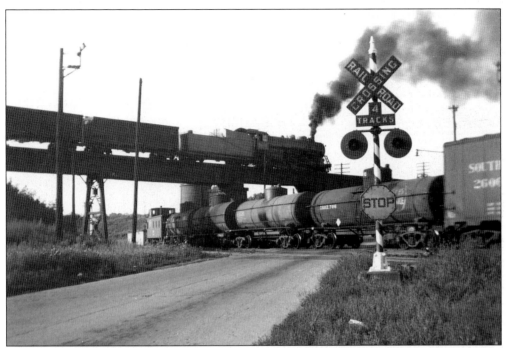

An eastbound Q freight passes over a southbound afternoon Missouri Pacific freight at the Dahlman Boulevard crossing, July, 1946. The South Omaha Terminal Railway enginehouse is out of the frame to the right. The C&NW also interchanged at this busy location.

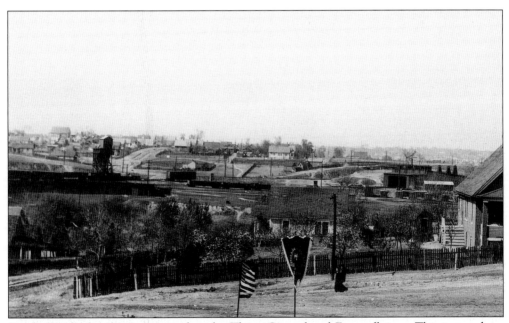

South Omaha locos were serviced at the Thirty-Second and F roundhouse. This image dates from April 28, 1924. (Durham Western Heritage Society photo.)

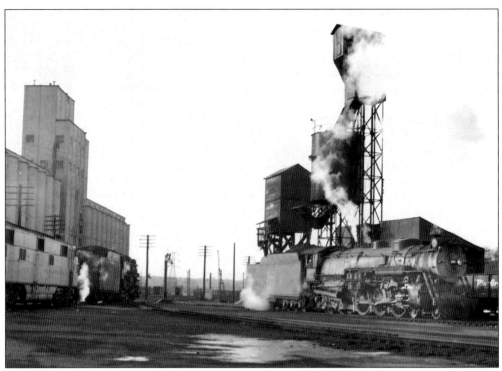

Two Hudsons and E units await assignments at Gibson Yard and engine terminal in 1950.

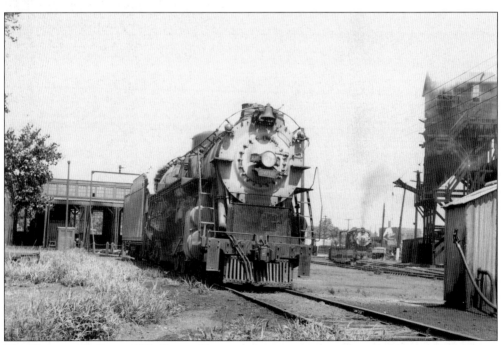

The Burlington's Council Bluffs roundhouse and engine terminal handled large power. This is a photo from July of 1949.

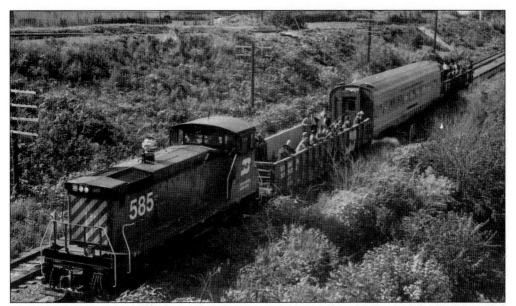

Burlington Northern's 585 departs from its regular yard chores to handle a special train through the Omaha area for customers and civic leaders on July 19, 1971. Sleeper Silver Birch is in the consist to provide toilet facilities.

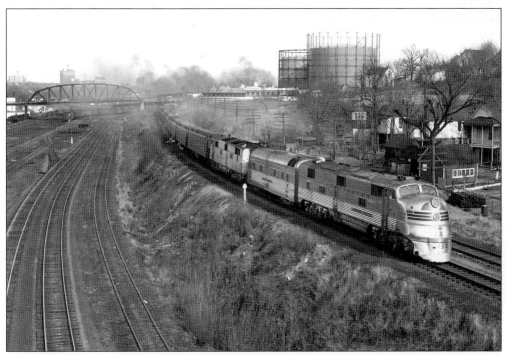

The shining E-5 type Silver Pilot, trailing a shovel-nosed unit, leads a Nebraska football special up the grade out of Omaha on November 24, 1951. Smoke in the background is from a westbound UP freight. At left is the Union Pacific's Martha Yard and the old main line to South Omaha. Note the unique Burlington concrete "Z" sign beside the second unit, signifying a "Zephyr" speed limit.

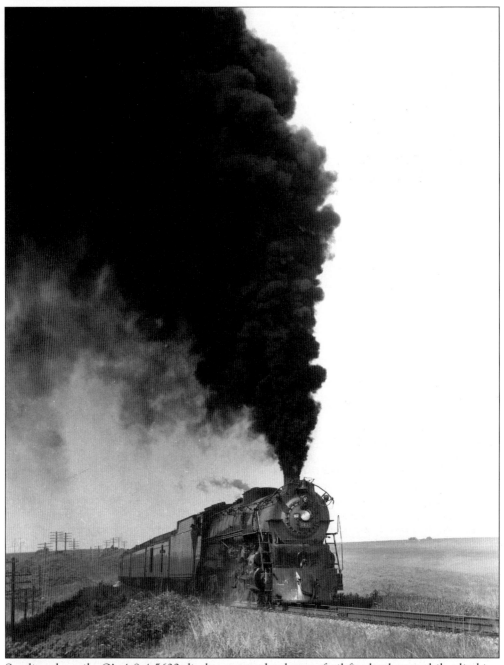

Sanding the rails, Q's 4-8-4 5632 displays a grand column of oil-fired exhaust while climbing the Denver-Chicago ruling grade near Melia, Nebraska with a steam excursion on June 3, 1962.

Three
THE NORTH WESTERN

The Chicago and North Western Railroad arrived in Council Bluffs on January 17, 1867. Transfers to the Union Pacific, already operating west, were made at Rapp's Station, a ferry landing on the Iowa side, and switched by the C&NW. During the winter of 1866–1867, and until the bridge opened in April, 1872, temporary pile structures were placed in the Missouri. These "ice bridges" allowed traffic to move west despite the frozen river.

Freight traffic was brisk as the C&NW garnered, by agreements, much of the UP's through business. The nightly meat traffic from South Omaha packing plants was given priority dispatching as it was on all roads. Eastbound business from the lines west included oil from Wyoming and grain. In the fall, it was common for seven or eight sections of cattle trains to be heading for South Omaha, one right after the other.

The road also operated a line from North Yard out to Irvington, and at one time had a connecting track from Debolt to the Omaha Road near Nashville.

The road operated passenger trains to Norfolk and western Nebraska, the latter locally called the "Long Pine train" because it stopped at that resort area en route to Chadron and Lander, Wyoming. Later, only connections were provided west to Lander from Chadron.

The Sioux City and Pacific built down from Sioux City to Blair to join the Omaha and North Western (Omaha Road), and gained access to Omaha via this route into Webster Street. The Chicago, St. Paul, Minneapolis and Omaha—the Omaha Road—was owned by the North Western but operated separately.

Omaha trackage was on the Nebraska side of the river. Passenger service was provided by a day (North American) and night (Nightingale) train to the Twin Cities, plus the Mondamin up the Nebraska side to Sioux City with connections to the night train. The Mondamin used Webster Street Station, which was originally shared with the Missouri Pacific until the MP began using Union Station.

Freight operations for the Omaha were handled by North Yard and its engine terminal in Omaha. Omaha trains operated on the Nebraska side to Sioux City via Blair. Unlike the level Iowa side, heavy trains out of North Yard usually required helpers to the summit near Nashville, Nebraska.

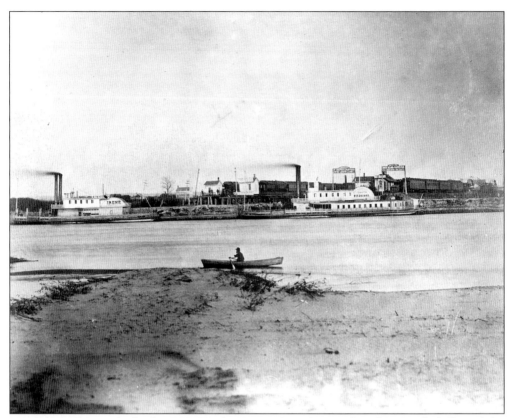

Until the bridge was built, the C&NW, the Kansas City, St. Joseph and Council Bluffs, and the Rock Island each maintained their own ferry slips on the Bluffs side of the river. (Union Pacific photo, author's collection.)

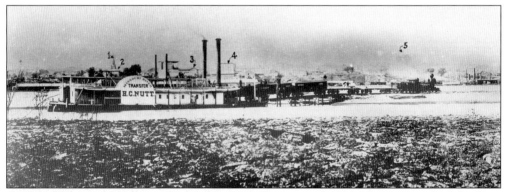

A North Western Mogul spots cars on the H.C. Nutt around 1871. The road worked the Iowa side, the UP the Nebraska bank of the Missouri River. The flat cars behind the loco serve as "idlers" to keep the engine weight off the boat. (Union Pacific photo, author's collection.)

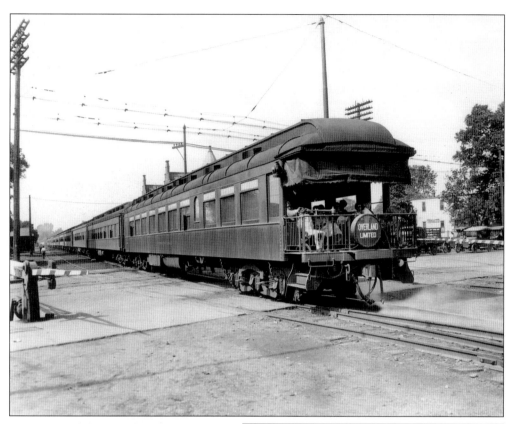

The Overland Limited makes a station stop in the Bluffs in 1921. Traffic tie-ups due to trains were common, particularly during World War II with all the passenger trains, light loco moves, and freight runs. (Bostwick photo, author's collection.)

The busy Broadway crossing was guarded by an elevated tower in April, 1946.

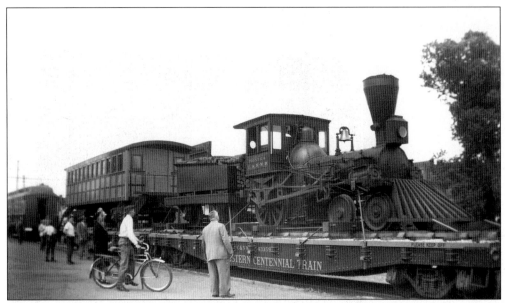

The C&NW's centennial train with the road's first locomotive, the Pioneer, drew much attention while on display at the depot in May, 1948.

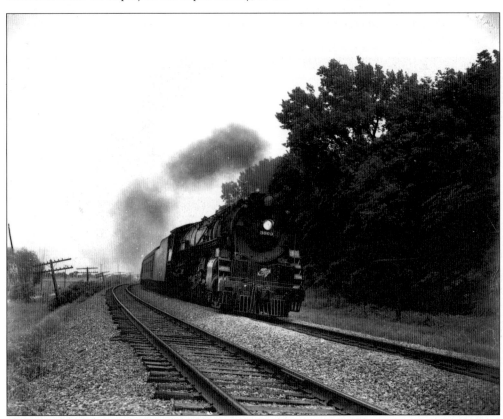

The last C&NW steam-powered passenger train heads into the Bluffs on June 9, 1953, behind H-1 type 3009.

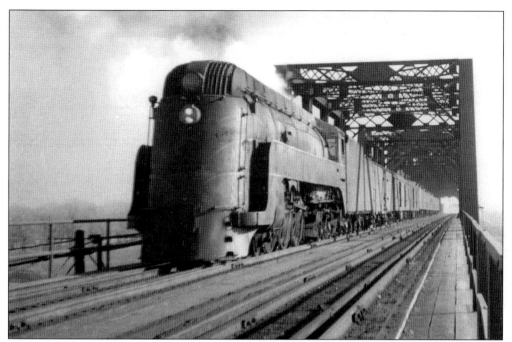

One of the morning fleet of the C&NW crosses the UP Bridge into Omaha in 1952 behind a streamlined E-4 type, built especially for heavy Chicago-Omaha assignments in 1938. (Thomas O. Dutch photo.)

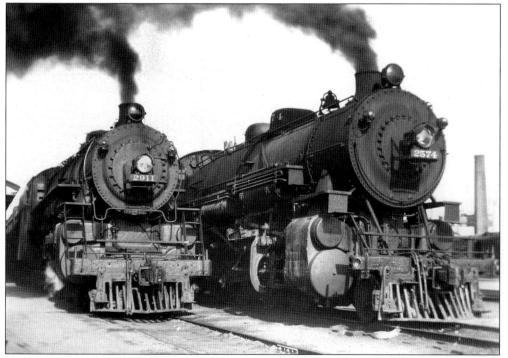

A morning mainline passenger train to Minneapolis is pictured beside a J class 2-8-2 on an eastbound troop train at Omaha Union Station, April 28, 1946.

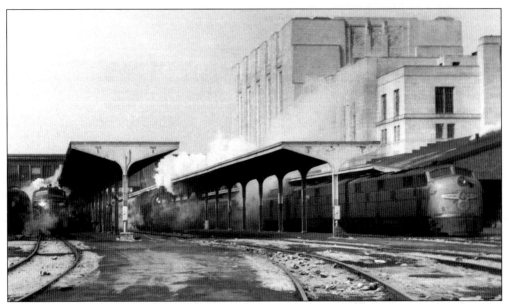

The Corn Belt Rocket, the Milwaukee Hiawatha (with standby power 4-6-2 160), and the Kate Shelly 400 of the North Western are all ready to head for Chicago in this photo taken at noon on February 17, 1951 at Omaha Union Station.

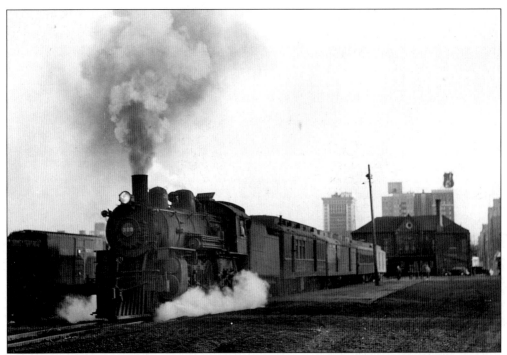

Owned by the North Western but operated independently, the Chicago, Minneapolis, St. Paul and Omaha—the Omaha Road—featured daily service up the west side of the Missouri River to Sioux City, Iowa with connections to the Twin Cities. The 6.20 p.m. Mondamin barks out of the old Webster Street station, April 7, 1949, headed for Blair, Nebraska and Sioux City. UP headquarters is up Fifteenth Street in the distance.

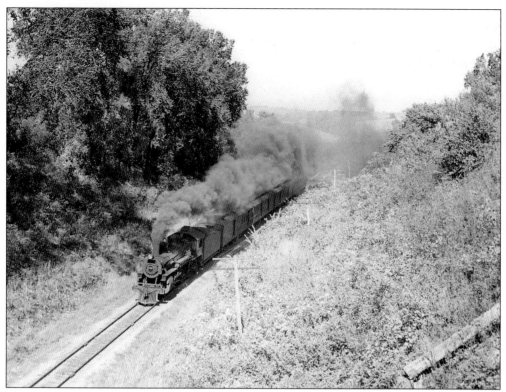
The Mondamin drifts through the deep State Street cut near Nashville, Nebraska on a warm fall morning in 1949.

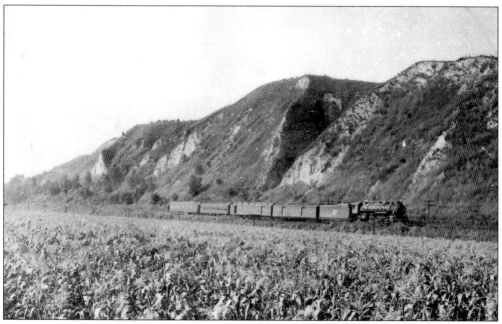
The Omaha Road's North American nears the Bluffs in 1945. Power is a heavy Pacific, modernized earlier for the steam-hauled 400. (C&NW photo, author's collection.)

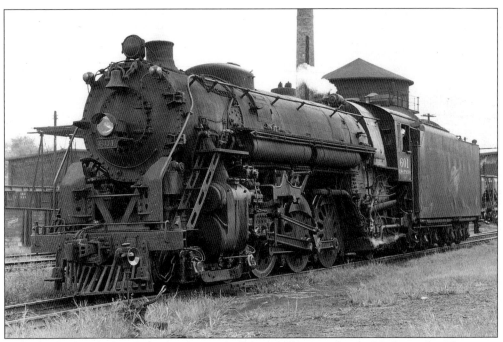

The nation's largest Pacifics were the regularly assigned power for the Nightingale. They were replaced in 1946 by F-M units. (Thomas O. Dutch photo.)

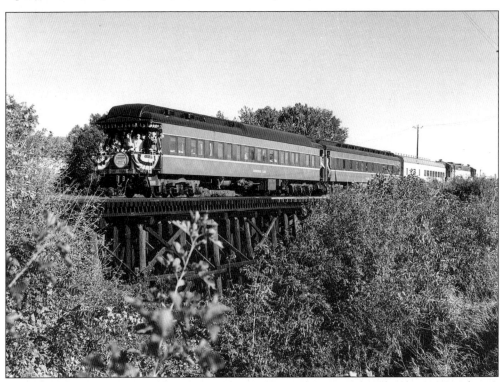

Congressman Glen Cunningham ran a campaign special to Lyons, Nebraska on October 6, 1968. The Special heads back to Omaha near Fort Calhoun. (Thomas O. Dutch photo.)

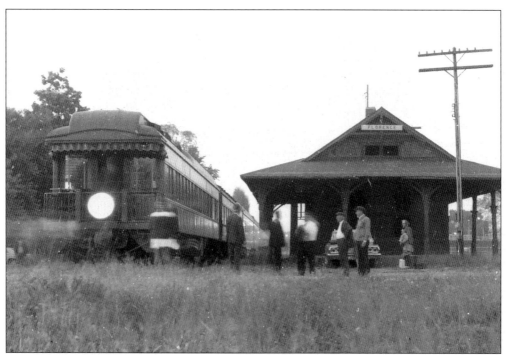

The last Omaha Road passenger train, a Nebraska football special to Minneapolis, loads at Florence depot, September, 1969.

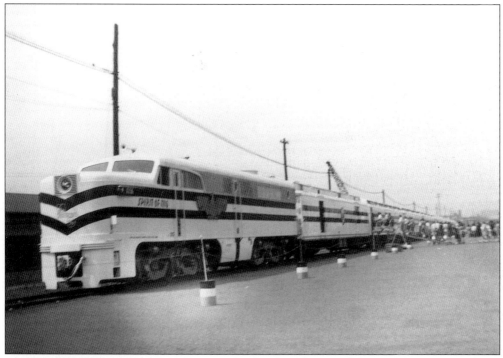

The Freedom Train was exhibited on Omaha Road trackage on May 14, 1948. The loco was appropriately numbered X1776.

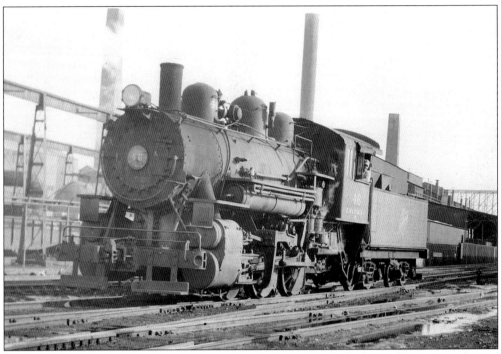

Drifting alongside the lead plant, 0-6-0 46 heads for North Yard after making a transfer run to the UP.

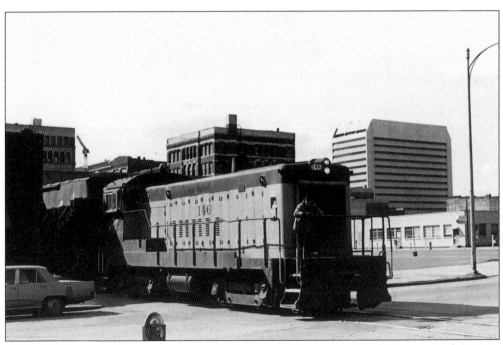

A North Western switch move spots cars in downtown Omaha near Tenth Street, April 5, 1981. (James Reisdorff photo.)

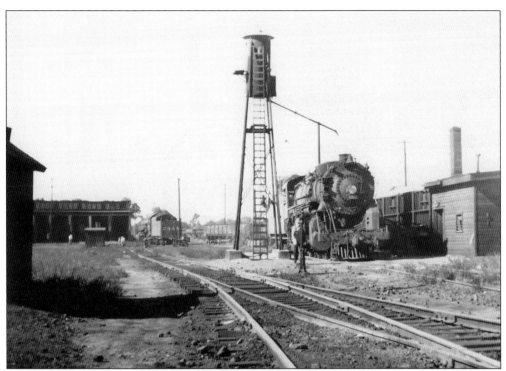

In this photo taken September 18, 1949, an Omaha Road 2-8-2 takes sand while a C&NW Omaha assigned J waits by the turntable to enter the roundhouse.

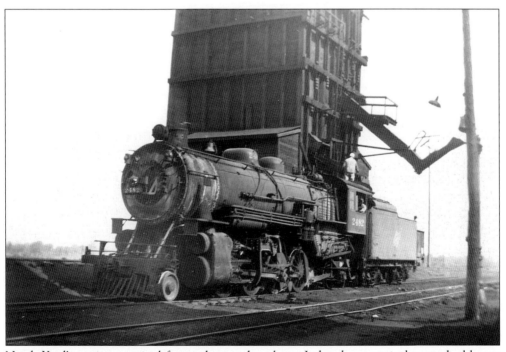

North Yard's engine terminal featured a wooden chute. J class locos were the standard heavy freight power. This photograph was taken May 2, 1948.

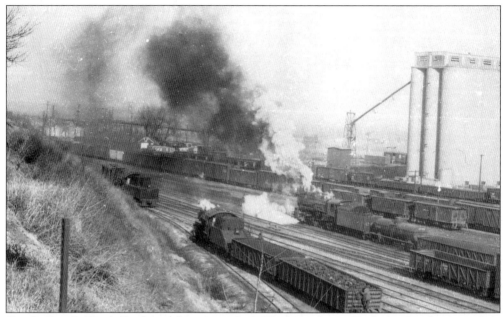

Omaha Road's North Yard was adjacent to the MP's Grace Street Yard. An Omaha J type 2-8-2 backs a cut to the MOP while MP switchers in the foreground work their own yard.

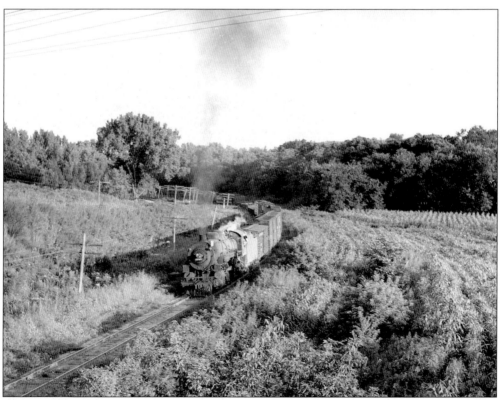

The evening manifest to Sioux City struggles upgrade near State Street in 1949. A J is on the point and a 2-8-0 shoving behind the caboose out of sight around the curve.

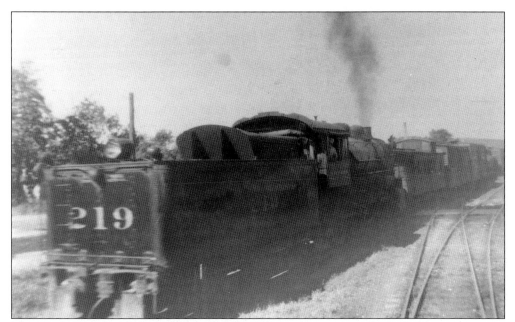

The North Yard switch loco also worked the helper jobs. In 1942, the Mondamin was in the siding as a northbound Omaha Road freight, with the helper shoving behind the caboose, passes Florence. (Vern Lenzen photo.)

A diesel freight growls north near Fort Calhoun, Nebraska, on February 26, 1972. (Thomas O. Dutch photo.)

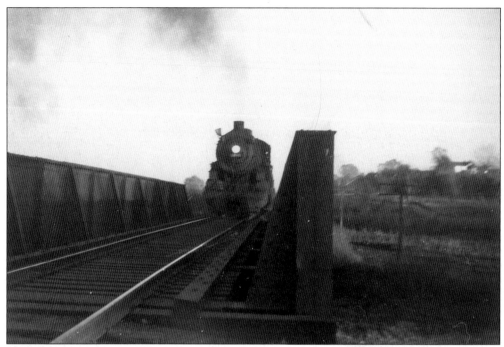

The Chicago and North Western entered Omaha from the Missouri River Bridge but also operated a freight line west from the Omaha Road yard on the river bottoms to Irvington, an outskirt community at the time. In 1945, a class Z 2-8-0 hammers upgrade crossing Florence Boulevard.

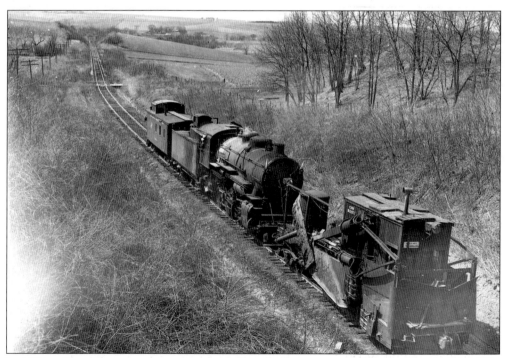

In 1954, a Z pushes a spreader train upgrade from Irvington near Debolt at the top of the hill.

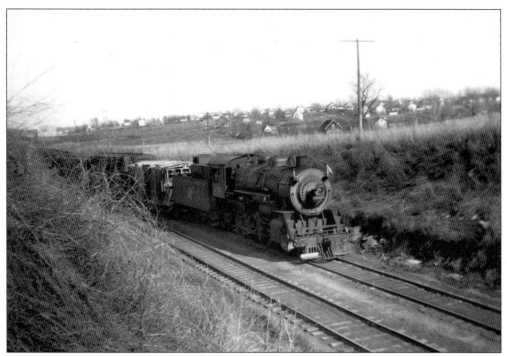

The North Western's line west operated out of their yard near Forty-Second Street. "Z" 1761, the "South O" switcher for years, is running extra on its daily turn to the Cargill Elevator at Dodge Street.

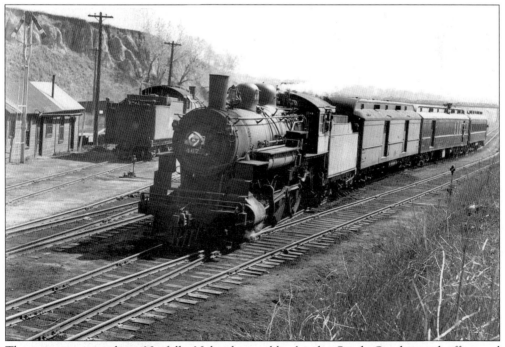

The morning varnish to Norfolk, Nebraska rambles by the South Omaha yard office and roundhouse, April, 1949.

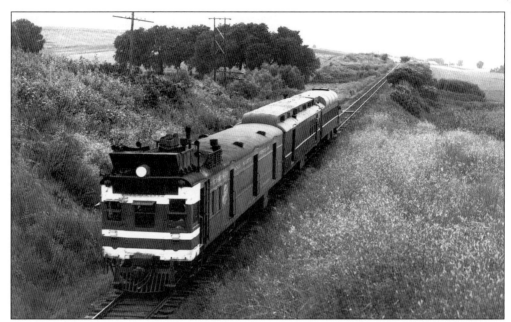

The Norfolk "motorcar" returns to Omaha just west of Irvington in 1953. During World War II, if extra cars for troop moves to the Scribner, Nebraska air base were added, the run was hauled by Atlantic type 1298 because the motor could not handle more than three cars up the Arlington and Omaha grades.

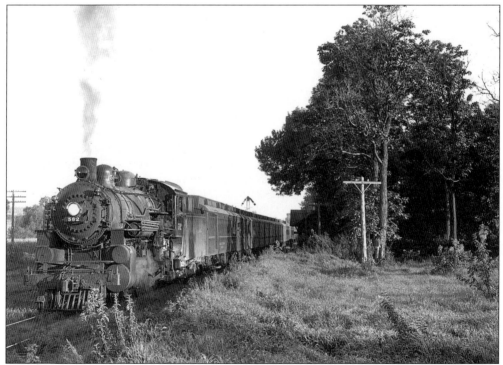

In August of 1953, the night train from Chadron, Nebraska pauses at Irvington, a junction of the east and west lines, while the crew registers to proceed on into Omaha.

Four

THE MISSOURI PACIFIC

In 1882, the Missouri Pacific entered Omaha from the south at Portal in the Papillion area from Weeping Water, Nebraska and operated into Omaha Union Station by agreement. The Belt Line around Omaha was constructed with UP funds in 1885–1886 and "suburban service" was instituted, complete with waiting sheds at various locations. The MP made a connection to the Belt near Forty-Eighth and Leavenworth Streets and transferred its passenger routing to the Omaha Road's new Webster Street Station. In 1889, the MP entered South Omaha from Plattsmouth, thus giving it two entries into town, and a trackage agreement allowed use of Omaha Union Station. In a strange turn of events, former UP official S.H.H. Clark privately seized control of the Belt. After discussions, the UP declined a legal battle and the Belt went to the famous Jay Gould and the Missouri Pacific which he controlled.

The MOP, as it was often called, contended with the UP and CB&Q for freight business to the south. Each road had its own circle of traffic supporters which actually caused the loadings to be about equal between the three lines. The MP route was a "hill and dale" road, and in the 1920s, ordered heavy 2-10-2s especially for the Omaha-Kansas City run to keep up overall train speeds.

By the 1920s and 1930s, passenger power into the Omaha area were 4-6-2s. In later years, heavy Pacifics handled trains along with rebuilt Mountain types. The star of the line was the 1940 Missouri River Eagle, an ACF-built streamliner which competed with the Burlington's Silver Streak Zephyr for the Kansas City trade and enjoyed the prime spot for the daytime St. Louis business.

While the mainline freight business was important, the Belt Line operations are best remembered by Omahans. Due to so many small industries along the Belt, several switch "jobs" were sent out of Grace Street every day. This included the "short belt," "middle belt," "long belt," and South Omaha jobs. The heavier jobs and yard work were handled by hefty 0-8-0s, the lighter work went to 0-6-0s.

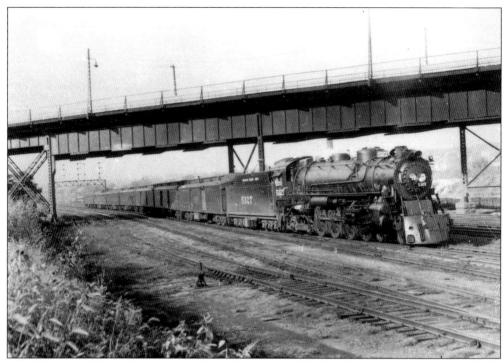

The MP overnight run from St. Louis and Kansas City, complete with diner-lounge, sleeping car, coaches, and head-end equipment, rolls into Omaha under the old Sixteenth Street viaduct in September, 1948. (Charles Duckworth Collection.)

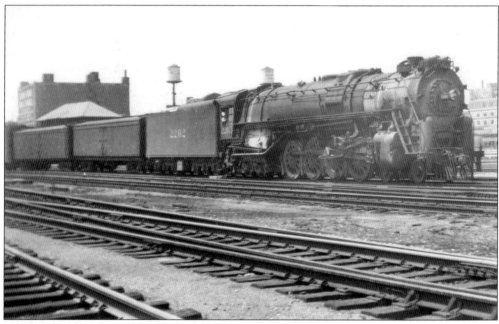

Floods further south on the MOP created motive power shortages, accounting for the first time one of the newest MP 4-8-4 types operated into Omaha, handling the five-hour-late Sunflower on June 24, 1947.

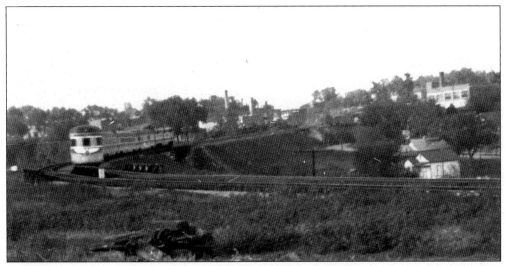

Until a loop track was built after World War II, the MP brought their Eagle up to the passenger yard via the Belt Line from South Omaha on evenings such as this one, in August, 1940. The morning run to the depot was made through UP trackage to Twentieth Street, then backing into the depot.

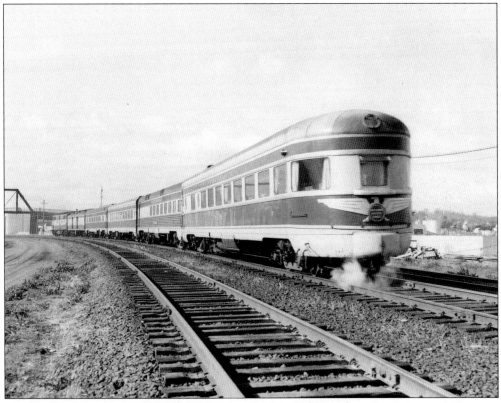

The Eagle still featured ACF-built parlor observations with speedometers in May, 1967.

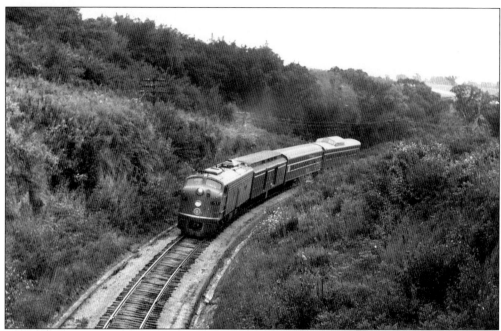

This photo depicts the last run of the Eagle, southbound, Plattsmouth, Nebraska, on September 7, 1965.

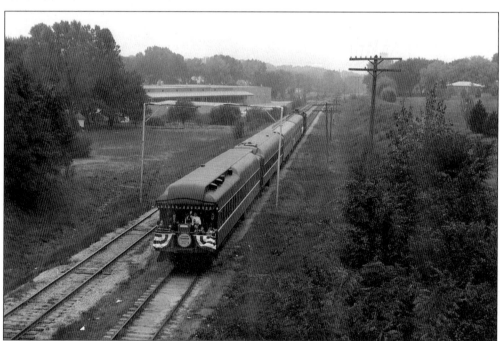

Congressman Glen Cunningham of Omaha operated a campaign train to Weeping Water on October 13, 1968. The train made up in the coach yard and deadheaded to South Omaha for boarding. The "DHQ", with ex-Pullmans Cornhusker Club and Glen Springs and two leased UP 6200 class lounge cars, rolls under the Center Street "telltale" and heads to South Omaha. (Thomas O. Dutch photo.)

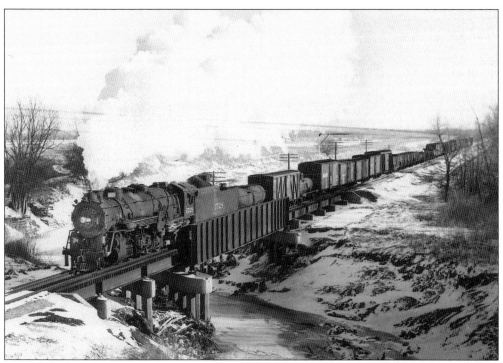

An Omaha-bound freight behind a 2-10-2 with auxiliary water car south of Gilmore Junction is pictured on January 21, 1951, not long before steam was removed from the Nebraska lines.

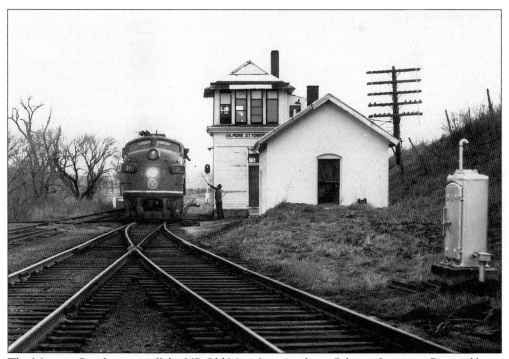

The Missouri Pacific came off the UP Old Main Line tracks at Gilmore Junction. Pictured here, the Eagle gets its orders, crosses over, and accelerates for Kansas City on April 18, 1965.

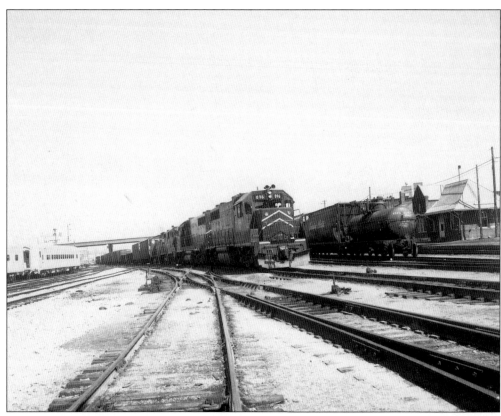

The MP had trackage rights over the South Omaha Terminal Railway to reach the South Omaha yard from the UP tracks from Gilmore Junction. A freight heads south in 1974.

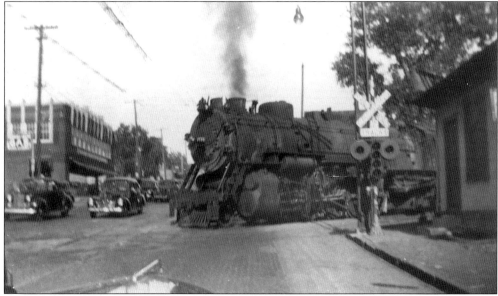

A northbound Belt Line freight behind a 2-10-2 crosses Leavenworth Street and the Ak-Sar-Ben line street car tracks in 1940. (Mike Connor Collection.)

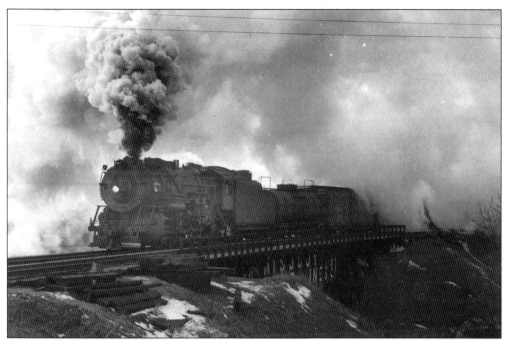

The last steam powered MP freight, crossing south Saddle Creek Road, was a southbound local to Falls City, pictured here on January 27, 1951.

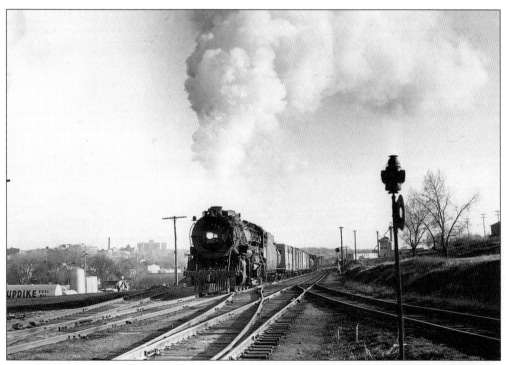

An afternoon inbound MP freight passes the Updike Fuel and Coal complex at California Street behind a 2-10-2 type. It was built especially for Kansas City-Omaha service and "set up" initially at the Falls City, Nebraska MP shop.

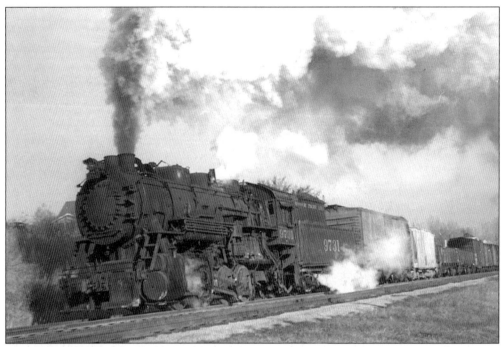

One of the impressive 0-8-0s struggles upgrade with a Belt Line "Long Belt" job at Wirt Street in 1951. (Thomas O. Dutch photo.)

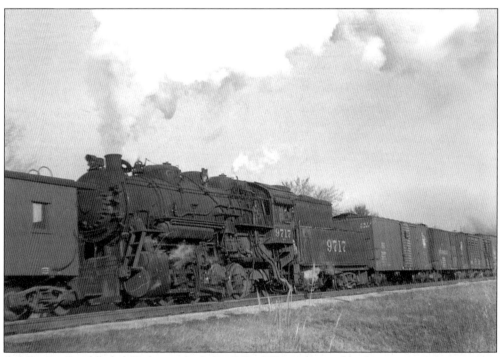

A following "middle belt" job couples behind the 9731s train, and both trains operate as one to eliminate delays on the busy Belt. (Thomas O. Dutch photo.)

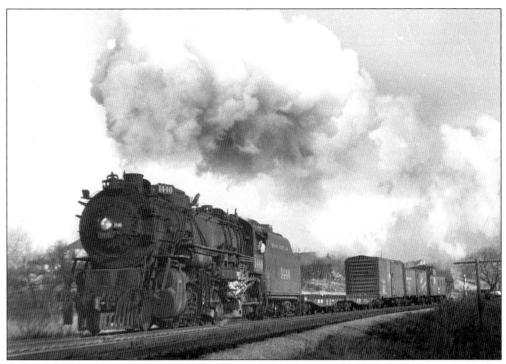

A heavy Mike with a light train heads upgrade, Wirt Street, 1951. (Thomas O. Dutch photo.)

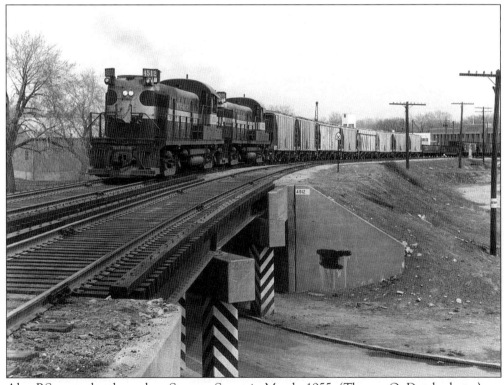

Alco RS power heads south at Sprague Street in March, 1955. (Thomas O. Dutch photo.)

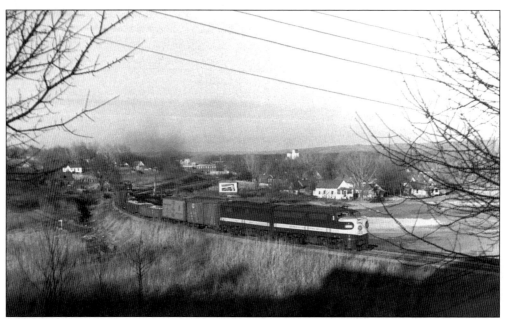

Almost-new Alco FAs climb up from the river bottoms near Wirt Street in November, 1952. (Thomas O. Dutch photo.)

Access to the MP coach yard and engine terminal was by a steep stairway from Fourteenth Street. In March, 1953, an Alco FA idles on the inbound inspection track. Across the yard the Sunflower prepares to head for the depot and its afternoon departure. (Thomas O. Dutch photo.)

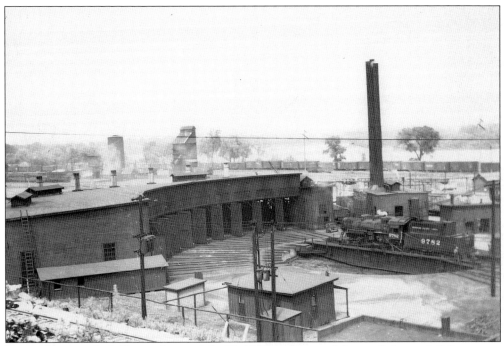

Pictured here is the MP roundhouse, July 28, 1948, with one of the road's heavy 0-8-0 types on the table. The Omaha Road engine terminal and coal chute are in the distance.

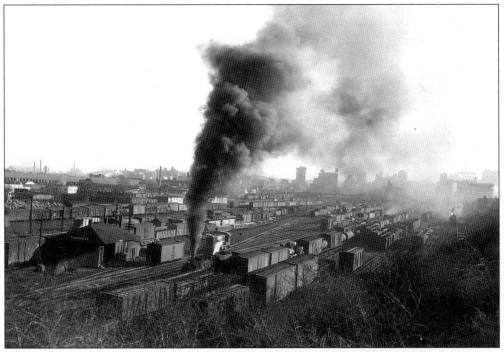

Pictured here is Missouri Pacific's Grace Street Yard, in October, 1950, showing the adjacent Omaha Road yard office and a new diesel switcher behind a heavy plume of coal smoke from an MP 0-8-0.

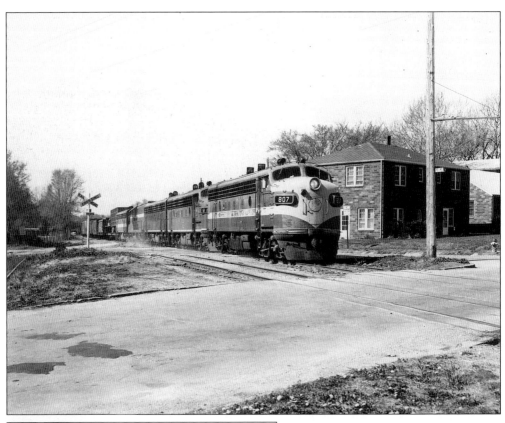

On occasions such as derailments on the main line, the MP utilized their original route into Omaha from Weeping Water. The northbound manifest is crossing Fiftieth Street in March, 1968.

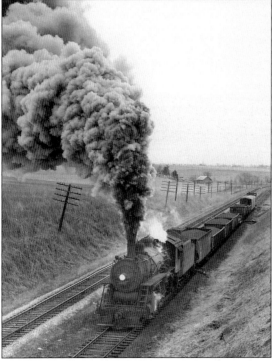

The daily (except Sunday) "sand train" heads for Louisville, Nebraska on the Weeping Water Branch on March 9, 1951, just west of Ralston.

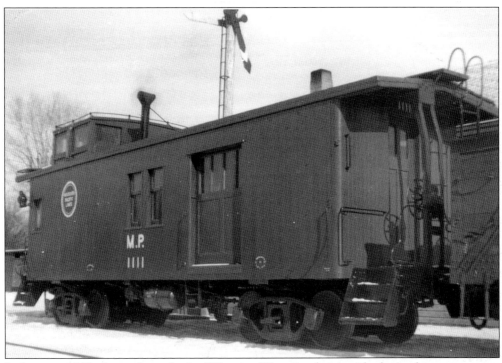

In January, 1947, those who rode the "Weeping Water" rode in a side-door caboose.

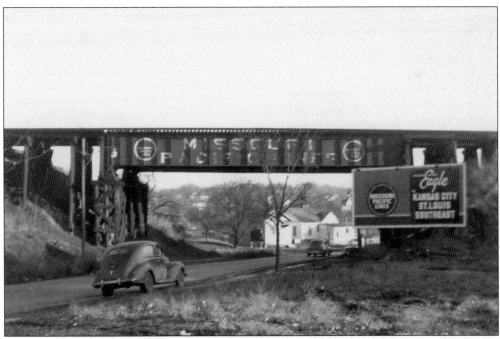

The Omaha Belt Line, originally built in the 1880s by the Union Pacific and later obtained by the MP in a suspect transaction by a former UP official, S.H.H. Clark, crossed south Saddle Creek Road on a wood and steel trestle and bridge. The Eagle was highly advertised at the time, thus the signboard. This picture was taken January 14, 1948.

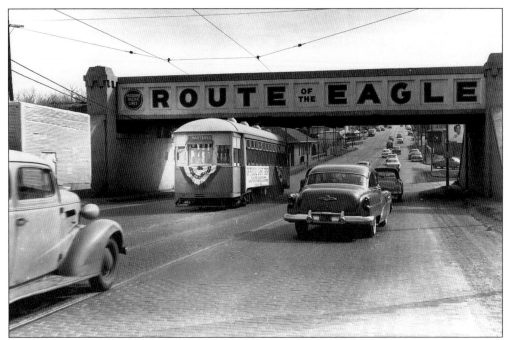

The last run of an Omaha and Council Bluffs Street Railway car passes under the Belt Line, March 5, 1955. The line between Cuming and Leavenworth Streets was double-tracked and raised over city streets during the World War I era.

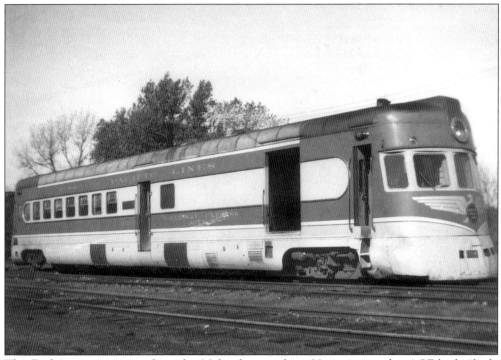

The Eagle's connection to Lincoln, Nebraska was from Union using the ACF-built "little Eagle." This picture was taken in Lincoln in 1947.

Five

THE ROCK ISLAND

The Chicago, Rock Island and Pacific—the Rock Island line—came into the Bluffs in June of 1869 as the Mississippi and Missouri. The road enjoyed good passenger traffic due to the large populations served across Iowa and Illinois. Even as late as the 1930s, three trains a day served Omaha and the Bluffs. In 1940, the famous Rocky Mountain Limited was superceded by a new, streamlined Rocky Mountain Rocket on the overnight run between Chicago and Denver, competing with the UP's City of Denver and the Burlington's Denver Zephyr. After the war, the road also added the Corn Belt Rocket to rival the Q's new Nebraska Zephyr service to Chicago.

Passenger traffic was reduced to only the Rocky Mountain and Corn Belt trains by the 1960s. The Denver run was cancelled first, followed by the last run of the Corn Belt Rocket in 1967.

Freight business on the Rock was always good from the east, particularly due to agricultural commodities. Freight locomotives were generally 2-8-2s, until later years when 4-8-4s, including the newer 5100s, were the normal manifest power. The 2-8-0s worked the Bluffs and Omaha yards and industries, and yard duties were generally handled by 0-6-0s. F type freight units ushered in dieselization, and EMD power dominated the loco pools with road switchers on both locals and time freights.

With the demise of the Rock, service was provided by the Iowa Interstate which operates its former trackage across Iowa. The original RI yard in central Council Bluffs was replaced by a completely new yard complex to the east in 1952. This included installing the last turntable built in the nation (until Amtrak's Lorton, Virginia table) because there were still 4-8-4s operating into the Bluffs during rush seasons. The UP recently joined the Interstate in operating a new inter-modal facility in the 1952 yard, and UP trains also operate in this yard.

Towards the end of the Rock, through service had been reduced to a single daily train east and west, often meeting somewhere in the general Omaha area depending on arrival times on a given day.

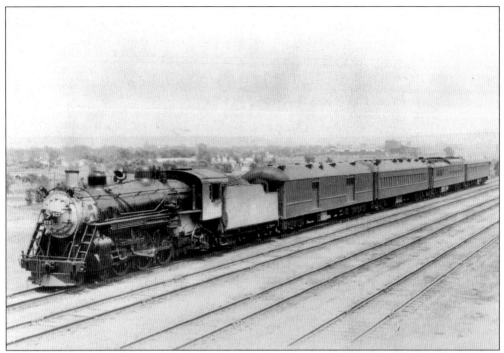

The Colorado Express heads west beside the UP PFE ice dock, heading for Omaha in 1938. (Richard Kindig photo, author's collection.)

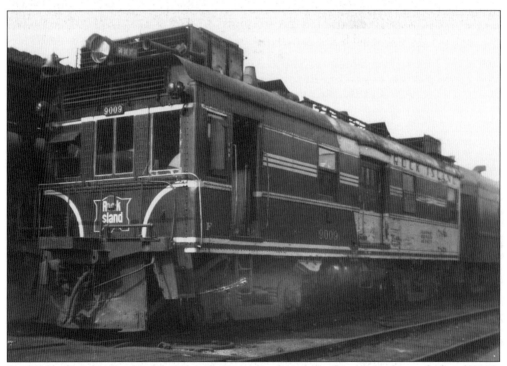

Rock Island's "plug local," the Colorado Express, often drew the unique box cab diesel 9009. This photo was taken in Omaha in 1946.

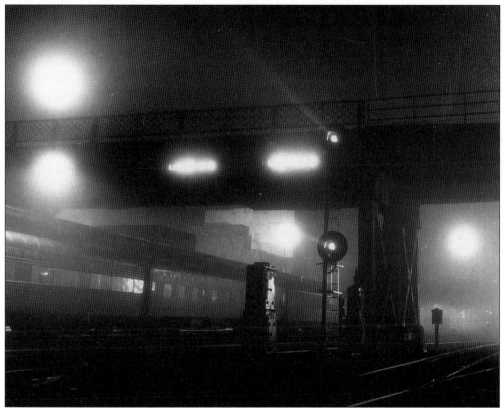
Fog surrounds the eastbound Rocky Mountain Rocket at Omaha Union Station in 1962.

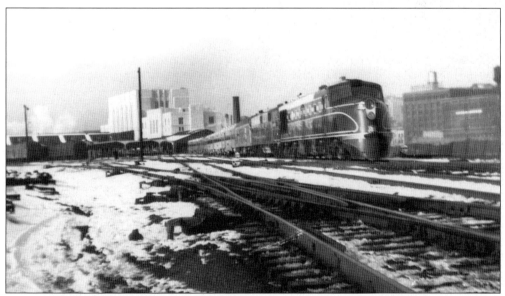
The Corn Belt Rocket accelerates out of Omaha Union Station behind an Alco on its first run, November 23, 1947.

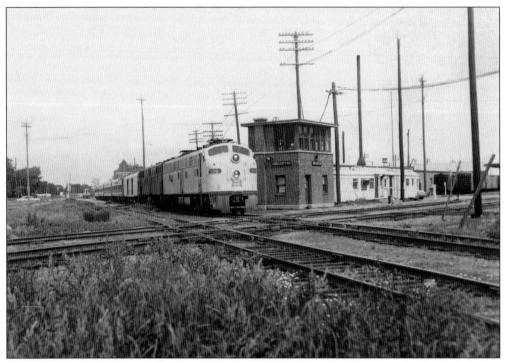

The last Corn Belt Rocket rolls away from the Bluffs depot, 1967.

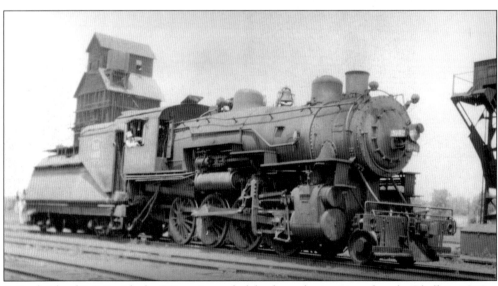

A Rock Island 2-8-0 with the RI's unique whaleback tender is pictured at the Bluffs in 1948.

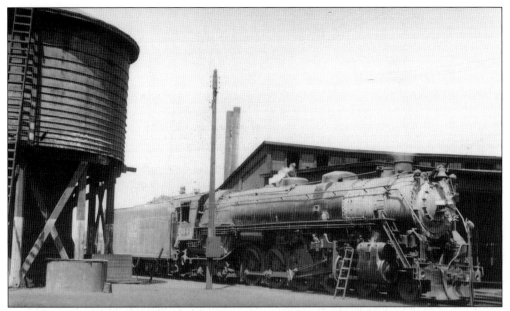

A big Northern type, just off an eastbound, is serviced at the Bluffs in 1948. Behind it is the wooden roundhouse. This class of power, still in use during fall rushes, necessitated the road installing the last new turntable in the nation (until Amtrak's Lorton, Virginia table in the 1980s) in the new 1952 yard.

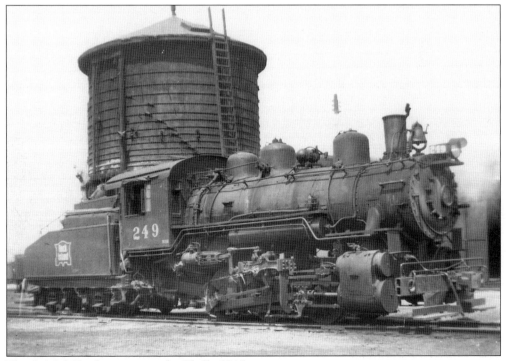

The 0-6-0 249 takes water at the Bluffs, 1948.

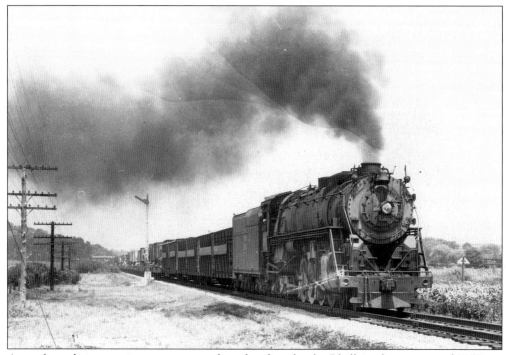

A westbound circus train passes a semaphore heading for the Bluffs in the summer of 1950.

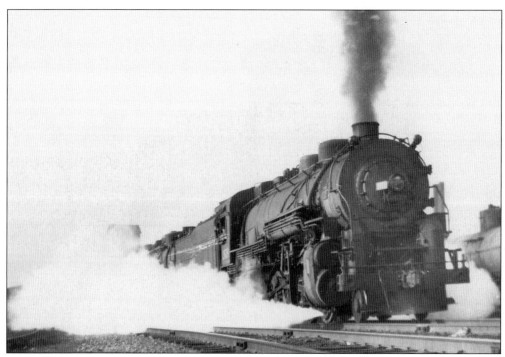

A Rock Island Mike clears its cylinder cocks getting under way out of the Bluffs in 1948.

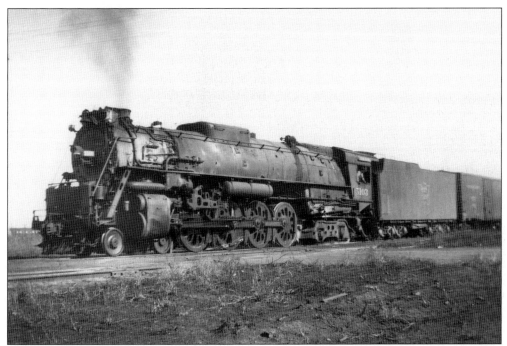

In the fall rush of 1949, one of the newest of the road's 4-8-4s was working through the Bluffs. The 5103 is departing for Denver.

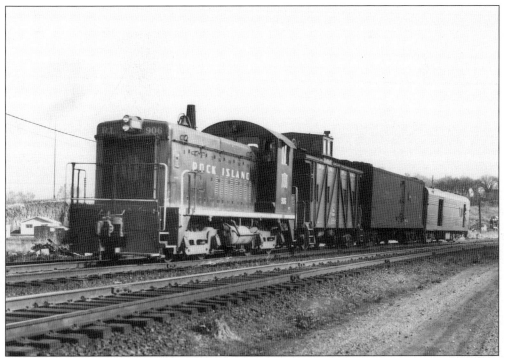

By the late 1960s, the Rock Island's "meat run" was often down to just a car or two. This day the run is also handling a Rock Island RPO headed for a repair shop.

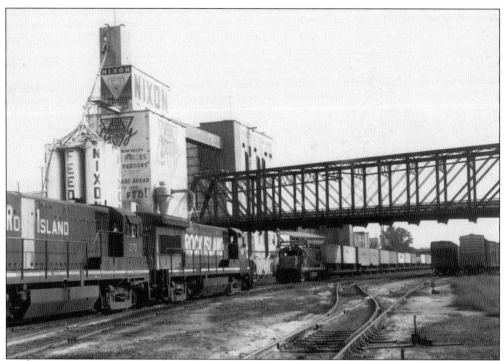

The meeting of the eastbound TOFC "hot" train from Denver and the westbound headed for Colorado was often an afternoon event in South Omaha.

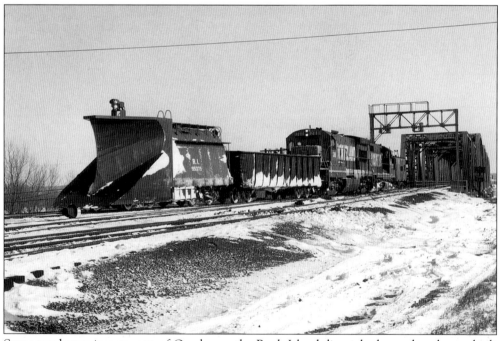

Snow was heavy in cuts west of Omaha, so the Rock Island dispatched a wedge plow, rebuilt from an ex-whaleback steam tender, to clean out the line. In this January 5, 1971 photo, the plow train is coming off the UP Bridge. (Thomas O. Dutch photo.)

Six

THE MILWAUKEE

The Chicago and St. Paul Railway entered the Bluffs in September of 1882 and later became the Chicago, Milwaukee, St. Paul and Pacific. Known generally as the Milwaukee Road, the line operated some of the Union Pacific's through trains between Chicago and Omaha until the depression era, and also had freight agreements with the UP.

The top passenger train in the 1930s was the overnight Arrow to the Windy City which competed with the Burlington, Rock Island, Illinois Central and even the Great Western (via a round-about routing through Oelwein, Iowa).

In 1940, in a move to "better the competition," the road offered a new train, the Midwest Hiawatha. The equipment from earlier versions of the Twin Cities Hiawatha service included the famous class A Atlantics of 1935. The Arrow was originally drawn by F-3 class 4-6-2s, but by the 1940s, class F-6 Hudsons held down the assignment. By 1946, these locomotives were superceded on a regular basis by the wartime-built S-3 Northerns. However, due to motive power situations out of Chicago, it was not uncommon to see any type of passenger power on any train, including the famous 1937 era F-7 Hiawatha locomotives. E class diesels came in 1948, were replaced by the As for several months in 1948 due to a diesel shortage, and then came back.

In 1955, the Union Pacific decided to move its Streamliners over the Milwaukee due to deteriorating conditions at the C&NW. The final passenger train to run out of Omaha was the road's City of Los Angeles, by then often referred to as the "City of Everywhere" because it had been combined with all other previous trains.

For years, freight power was provided by standard L series 2-8-2s and locals with 2-8-0s. In later years, the big S-2 Northerns were often used on the heavy manifest runs. Switching was performed by 0-6-0s and 2-8-0s, and on occasion, even 2-8-2s did yard work. In a power shortage in early 1947, the road borrowed UP 2-10-2s, but they were quickly returned because of bad steaming due to coal differences.

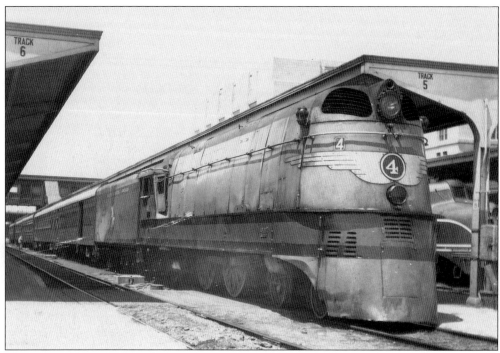

The Milwaukee's Omaha-Chicago Midwest Hiawatha service was highlighted by the famous original A type Atlantics until mid-1946, and again in 1948 for a short period. The Hi was normally on tracks adjoining the competition's Corn Belt Rocket at Omaha Union Station.

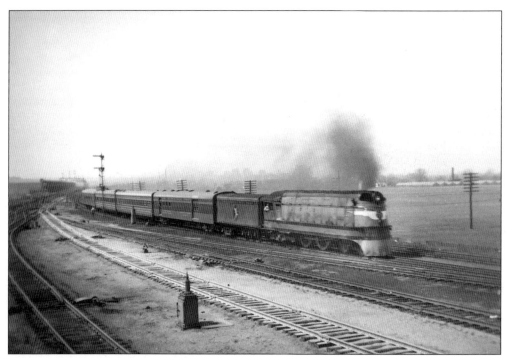

The Hi rolls past the windows of Tower A in the Bluffs, April, 1946.

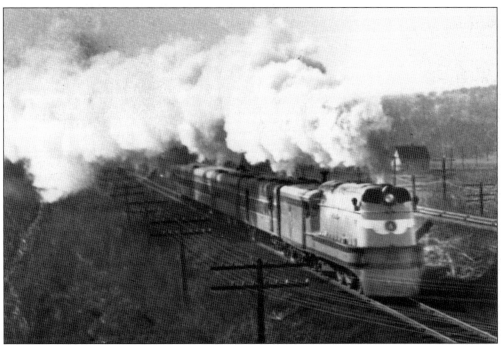

The Midwest Hi is already hitting the high spots south of the Bluffs in 1941. (Fred Petersen photo.)

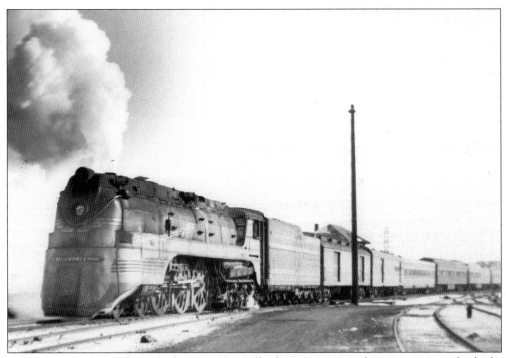

The overnight from Chicago, the Arrow, usually drew S-3 4-8-4s, but on occasion the high-stepping F-7 streamlined Hudsons of Twin Cities Hiawatha fame were assigned. The 104 comes into Omaha Union Station on a bitter cold morning in January, 1947.

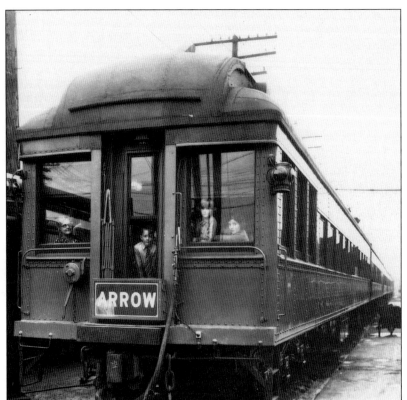

In order for the Arrow to better compete in the Chicago overnight traffic, the Milwaukee rebuilt two open platform observations, the Waucoma and Maquoketa, into solarium sleeper observation lounge cars in the early 1930s.

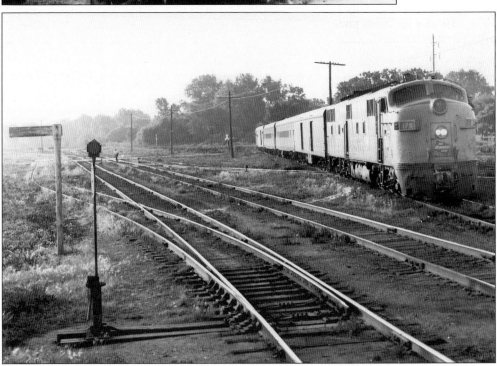

The last westbound Arrow nears the Bluffs Transfer junction in May, 1967.

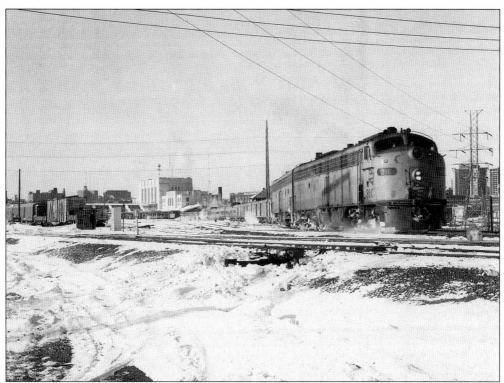

The Milwaukee assumed operation of UP trains to Chicago in 1955. Running late, the eastbound City of Los Angeles departs Omaha Union Station in the daylight on January 5, 1971. (Thomas O. Dutch photo.)

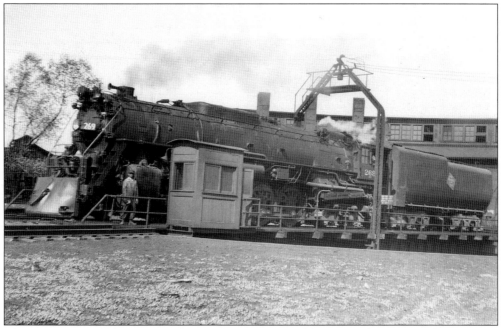

The 269, just in off the Arrow, takes a ride on the turntable at the Bluffs on April 6, 1946.

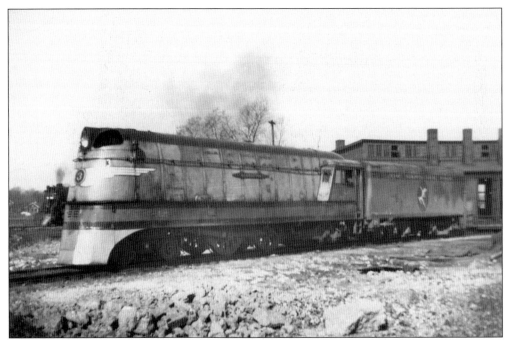

At 9 a.m., the Hiawatha's class A is ready to go to its train. In the distance is an S-3 just releasing from the Arrow back in the coach yard and heading for the house, April, 1946.

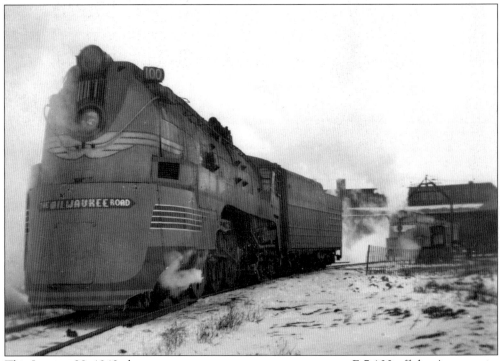

This January 28, 1948 photo captures an uncommon occurrence—F-7 100 off the Arrow waits for the Hiawatha's class A to come off the table.

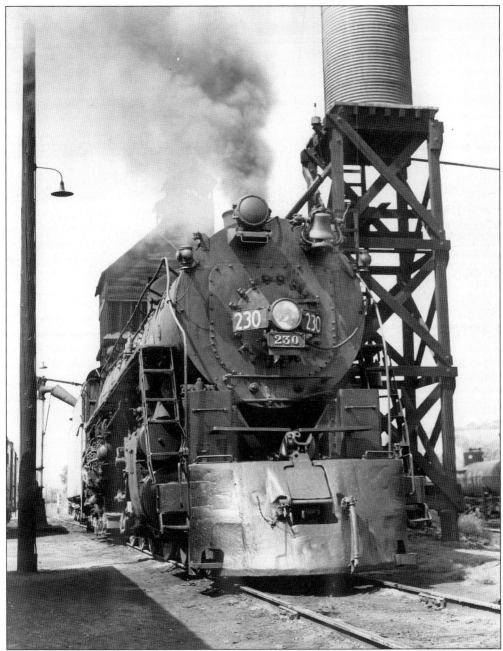

Northern 230 takes on sand and water at the Bluffs in July, 1953. (Thomas O. Dutch photo.)

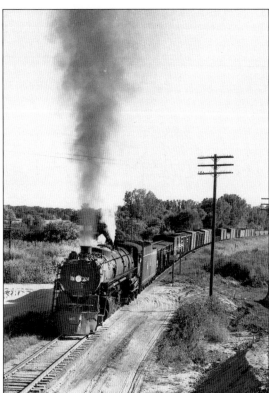

The S-2 4-8-4s were the largest power into Omaha on the Milwaukee. The 224 gets a manifest underway from the Bluffs in July, 1953.

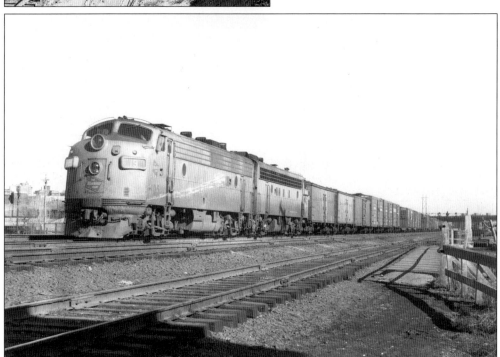

A Milwaukee "bridge run," with several meat cars in consist, climbs the grade to South Omaha over the UP in 1974.

Seven
THE ILLINOIS CENTRAL

The Illinois Central came into Council Bluffs in December of 1899 from Fort Dodge, Iowa. Passenger service had earlier been limited to day and night trains, but by the late 1930s, only the overnight Hawkeye to Chicago remained. It was removed abruptly in 1939. The IC's own traffic men were not told of the discontinuance until the day before, although of course, proceedings had been going on with the ICC.

IC passenger trains used their bridge into Omaha and ran up to Twentieth Street, then back into the depot. Outbound trains reversed the procedure, backing out of the depot.

Due to traffic agreements with the Union Pacific, the road enjoyed good freight revenue, particularly with eastbound fruit. Like all roads, the IC also shared in the nightly meat train business to Chicago. The 2-8-2s were the mainstay of IC freight assignments while 0-6-0s worked the yards. To gain access to the lucrative Omaha industries, particularly grain, in the early 1900s, the road constructed a long wooden trestle from the river bottoms near Carter Lake upgrade to the Sixteenth Street area on top of the Nebraska hills. The IC used auxiliary water cars with the 2-8-2s after water service was cut back west of Fort Dodge in the late 1940s.

The line became the Chicago, Central and Pacific under new ownership in the 1970s. In the 1990s, the road went back to the IC, but now is part of Canadian National ownership.

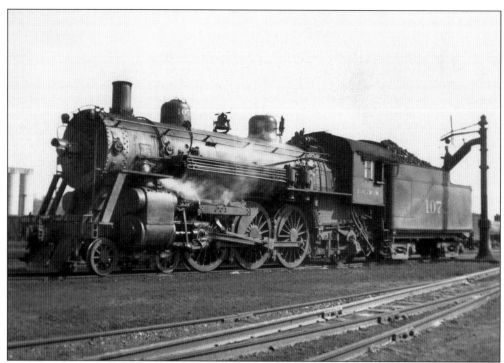

The Hawkeye's power takes water in the Bluffs engine terminal in 1939. The loco is just in from Fort Dodge, junction to the mainline to Chicago. East of there the train required a 4-8-2 which operated out of Sioux City. (Jack A. Pfeifer photo.)

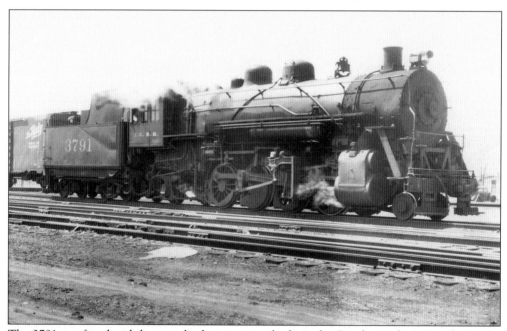

The 3791 was fitted with larger cylinders to assist climbing the Omaha grades to South Omaha for the meat business. Pictured at the Bluffs in 1951, the 3791 was one of two such modified locos assigned Council Bluffs.

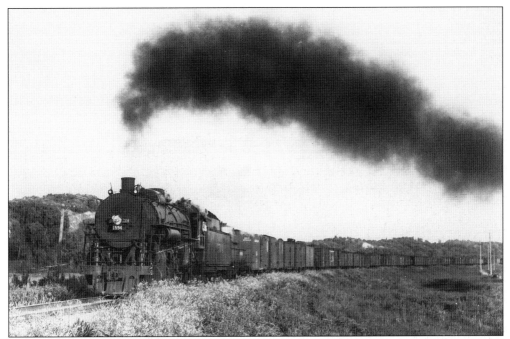

The meat trains, including the Illinois Central's, came out of Omaha in the early evening and were "hot" trains to Chicago on all roads. The nightly IC train, behind auxiliary tender-equipped 2-8-2 1594, rolls out of the Bluffs in July, 1952. The meat was handled behind the power, this evening about six cars head for the Chicago market.

Wilson's orange reefers were familiar in South Omaha. The IC assembled this string for a publicity pose in the 1950s on UP trackage near the plant. (Illinois Central photo, author's collection.)

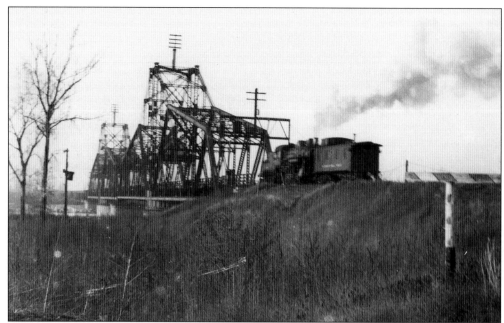

In 1939, an IC "transfer run" heads for Omaha over the IC's 1900-era swing bridge, which was used until the late 1980s when the IC received trackage rights to use the UP Bridge. The bridge is still in place but is not in operating condition, although rebuilding plans were prepared in the 1990s. It is now in open position, but held from scrapping by the thought of further use in the event that something happens to the UP Bridge, the only other one close to Omaha on any road. (Jack A. Pfeifer photo.)

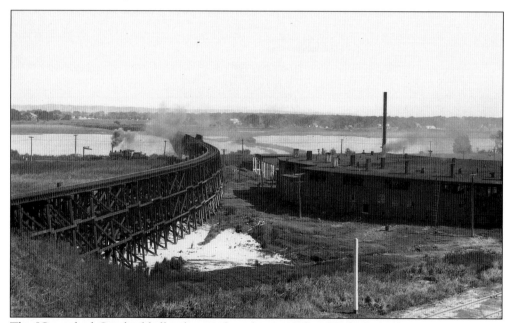

The IC reached Omaha bluff industries by a long wooden trestle from the river bottoms. A girder bridge spanned the Omaha Road below. The Missouri Pacific roundhouse is at right. (Durham Western Heritage Collection.)

Eight

THE GREAT WESTERN

The Chicago Great Western arrived on the scene in November of 1903. The line was rarely burdened with heavy traffic, with the exception of grain rushes. Passenger-wise, day and night service was afforded to Chicago and the Twin Cities, but the Illinois connection was through Oelwein, Iowa so there was little competition. By the 1930s, passenger service was down to a day and night train to the Twin Cities. The Great Western declined to enter the new Union Station contracts of 1931 and worked out an arrangement with the Burlington to use their depot instead. In the 1950s, passenger service was reduced to only the night run to the Twin Cities, and that operation ended in September, 1965.

Motive power for the Great West was 2-8-2s with auxiliary water cars on time freights, and 2-8-0s on locals and for yard work. The day passenger run drew 4-6-2s while the night train had 4-6-0s. The roundhouse was in lower Council Bluffs near the Rock Island-Milwaukee depot.

The Great Western was later absorbed by the Chicago and Northwestern, and much of its property and trackage in the area was abandoned or sold, including the almost-new diesel shop and station in the Bluffs. In the late 1920s Great Western constructed the earliest TOFC facility in the area and began transporting truck trailers, a true novelty in those days. While the traffic never grew to a large amount, it was a unique fixture in the area—way ahead of its time.

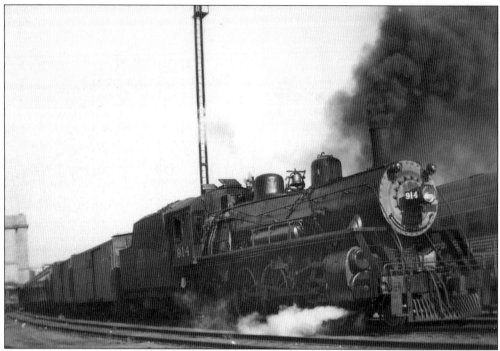

The CGW passenger trains operated out of the Burlington Station in Omaha after 1931, due to the high fees of the new Union Station. The Twin Cities Express prepares to depart for the Twin Cities in 1946.

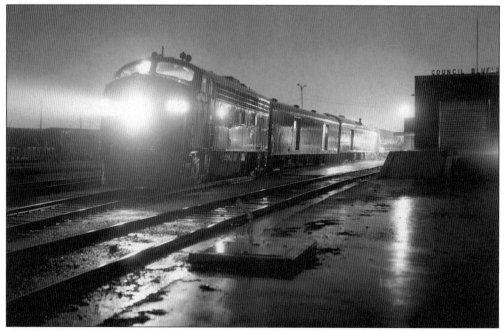

The last CGW passenger run makes the stop at Council Bluffs' comparatively new station on a rainy September 29, 1965 en route to the Twin Cities. The CGW used ex-Milwaukee Hiawatha coaches on the train in later days. Before that, buffet-sleeper observations were also in the consist.

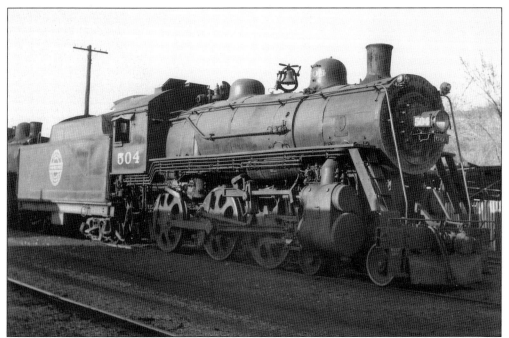

The night train to the Twin Cities was assigned 4-6-0s, modernized with disc drivers. This picture dates from March of 1949.

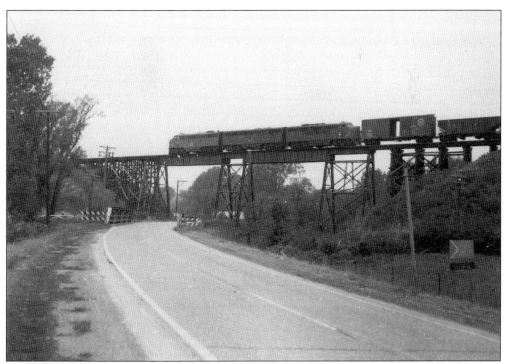

A northbound CGW time freight, behind F units, crosses Highway 6 near Council Bluffs on September 30, 1965. Freight business was never heavy on the road, except during grain rush periods.

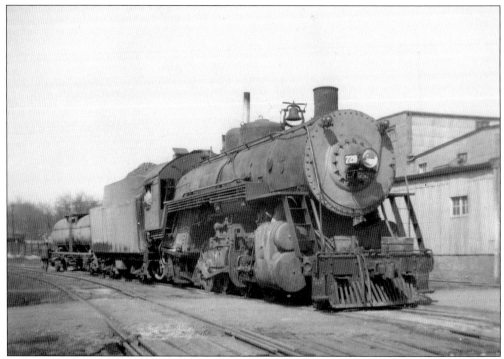

The 2-8-2s with auxiliary tenders were the Great West's heavy manifest power. This Council Bluffs photograph was taken in 1948.

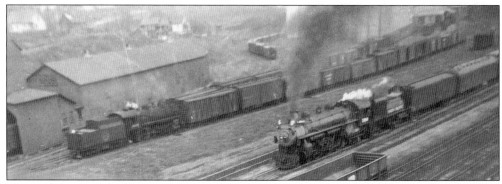

The CGW served the Omaha grain elevators near Martha Street by trackage rights. A CGW 2-8-0 shoves boxcars into the elevator as a westbound UP extra heads up to Summit, 1942.

Nine
THE WABASH

The Wabash Railroad entered Council Bluffs in August of 1880. The tracks came through Malvern and Silver City, Iowa from a junction at Brunswick, Missouri near Moberly. Train movements were always lighter than on most of the other roads, and the line became a branch of the Norfolk and Western in later days. It was abandoned in the 1980s and its roadbed now forms the Wabash Trail path.

By the 1930s, passenger operations consisted of a day local and an overnight train with a sleeping car from St. Louis. By World War II, only the overnight was operating as the St. Louis Limited eastbound, the Omaha Limited westbound. Passenger trains operated into Union Station, Omaha, with a stop also at their Bluffs depot.

Freight trains were assigned small 2-6-2s on all but the manifests which normally drew 2-8-2s. A small stable of 0-6-0s worked industry and interchange moves. The passenger trains used 4-6-2s, in later days complete with new cast pilots. Diesel operation was by E units on the passenger run, hood and road-switchers on freight and yard assignments.

Much of the former Wabash property is now operated by the Council Bluffs Railway.

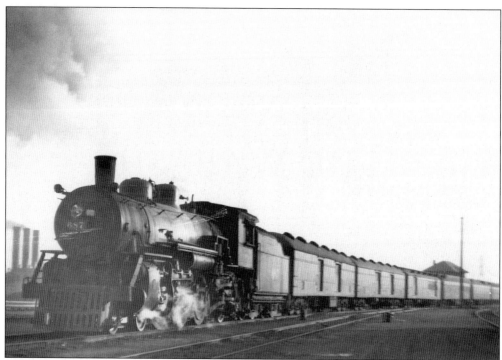

The Wabash Omaha Limited comes into Omaha in December, 1947, behind one of the road's modernized Pacifics.

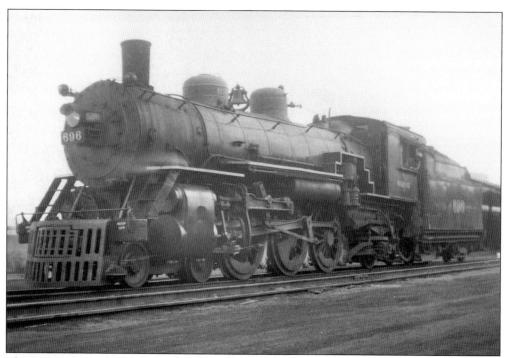

The 696, with cast pilot, shared the Wabash night train to St. Louis power assignment with the 687 for years.

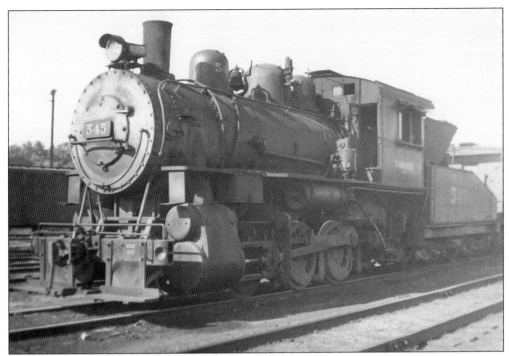

The Limited was towed over to Omaha each afternoon from the Bluffs' Wabash yard by an 0-6-0, which worked the interchange with the UP at Seventh Street yard after spotting the varnish in the depot. A goat also brought the Limited back in the morning.

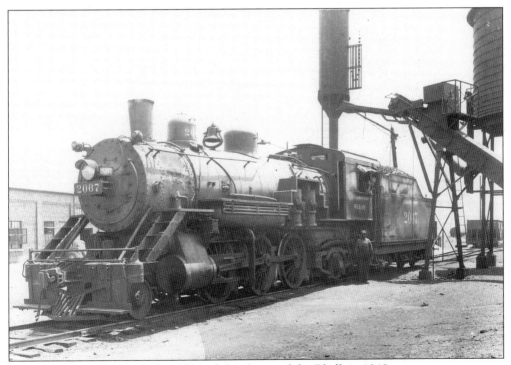

Light prairie types were used on Wabash locals out of the Bluffs in 1948.

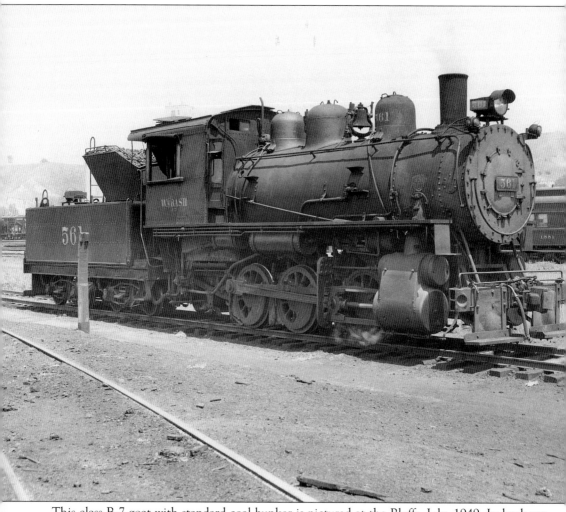

This class B-7 goat with standard coal bunker is pictured at the Bluffs, July, 1949. In back are the coach track and the overnight from St. Louis, which is being serviced.

Ten

THE OTHER ROADS

Besides the nine major carriers which served the area, other operations were important to various aspects of railroading in Omaha and Council Bluffs.

The Nebraska Power Company hauled coal to its Fourth and Jones plant, utilizing O&CB trackage.

The Union Stockyards Railway was built in the 1880s to serve the stockyards. It became the South Omaha Terminal Railway as a common carrier in 1927, and was sold November 1, 1971 to the Auto-Liner Corporation. The Brandon Railroad superceded the SOT.

The Omaha and Council Bluffs Street Railway was the first major electric street railway system in the nation and began in the 1880s. The last revenue run was on March 4, 1955, followed the next day by a ceremonial turn to Fiftieth and Underwood and back with local political leaders and businessmen.

The Nebraska Traction and Power Company line served downtown Omaha and went west to Papillion. Coming late to the scene, it ceased operations in 1926.

The Auto-Liner Corporation began working with the Canadian National Railway and local Paxton-Vierling-Steel Company to develop auto-carrying systems for passenger trains, and operated a full passenger and freight car shop operation until 1977. It is now Nebraska Rail Car. It also operated the famous Nebraska football trains.

Amtrak has had a daily train through Omaha since the beginning of its service. It first utilized the Burlington Station because the train operated on that road. In the 1970s Amtrak gave some thought to moving to the ex-Omaha Union Station. After researching operational problems and the reluctance of the UP to allow changes in trackwork to accommodate the necessary new routing, Amtrak still runs the California Zephyr over the Burlington Northern-Santa Fe route.

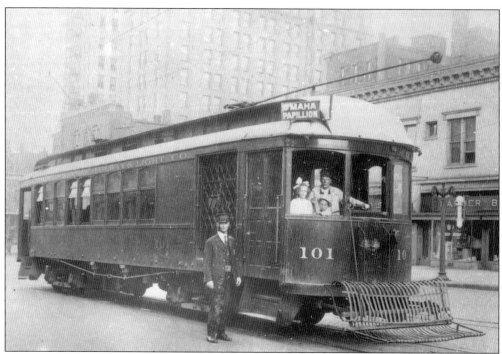

The other electric operations in the area were interurban lines, the Nebraska Traction and Power Company interurban (shown downtown) to Papillion, and the Omaha and Southern to Bellevue. Both were gone by the depression. (George Kieser Collection.)

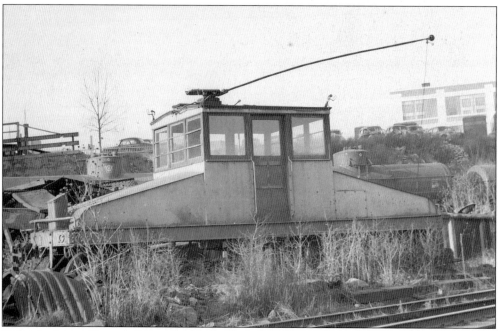

Nebraska Power Company's steeple cab handled all switching duties and was inherited from the O&CB sale in 1929. In March, 1949, it was headed to scrap but was not cut up by Aaron Ferer until the summer of 1952.

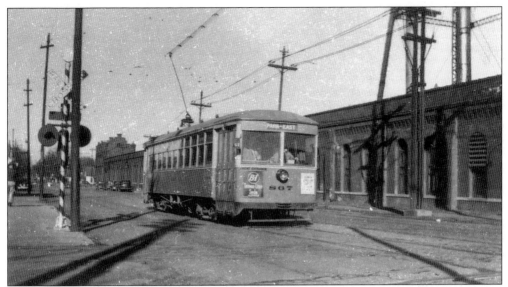

The original "model car" for one-man cars in Omaha was the 867, passing the Ames car barn in 1947. (Henry Hamann photo, Ray Lowry Collection.)

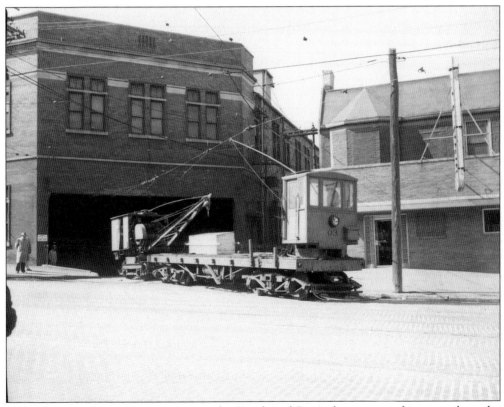

The O&CB work car 03 and crane, at the Tenth and Pierce barn, were often seen along the system doing maintenance work. Pierce was the last active barn.

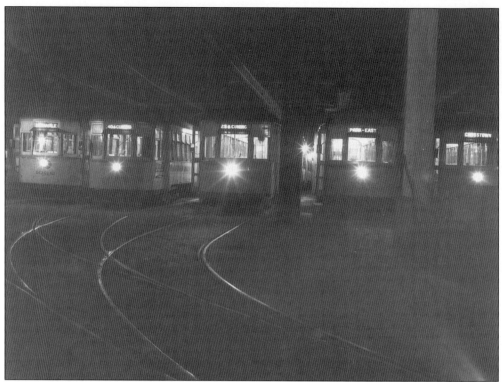

This is a night scene in the Pierce street carbarn, March, 1952.

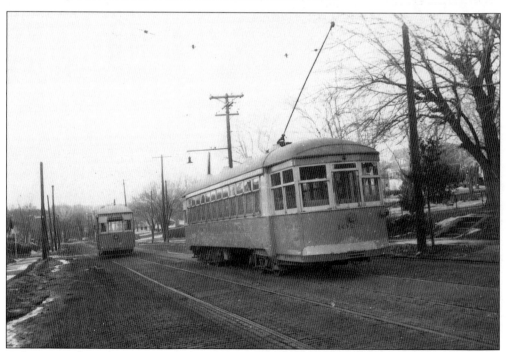

A downtown-bound car comes off the single track end of the North Forty-Fifth line at Bedford Avenue, while a car headed for the end of the line waits on the double track in 1955.

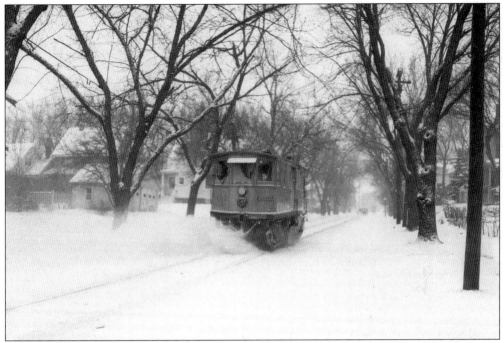

A sweeper clears Fiftieth Street on the Dundee line in January, 1951. Trailing behind is a salt car converted from an 1890s car.

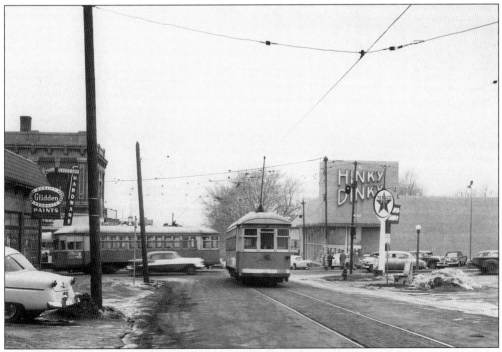

A downtown-bound car turns the corner at Fiftieth and Underwood, while a car headed to the end of the line waits for the clear signal on the pole at right. A second signal was just down the street in front of the store. This picture dates from March 4, 1955.

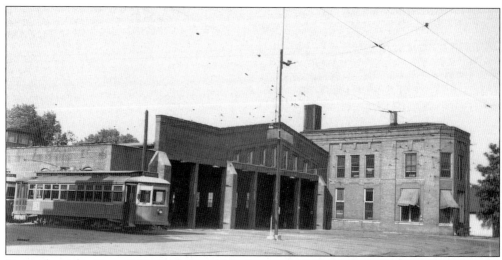

Pictured are the Council Bluffs barn and headhouse in 1948. These buildings still remain and are used by a local firm.

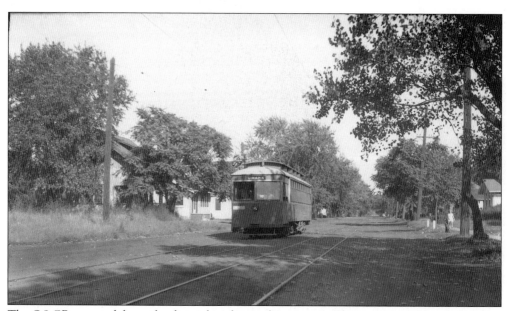

The O&CB operated down the dirt right-of-way of Avenue A. The car pictured here is heading for Omaha in 1948.

The Council Bluffs Railway interchanges in the Bluffs and operates what are basically the ex-Wabash facilities. This picture was taken in May, 2001.

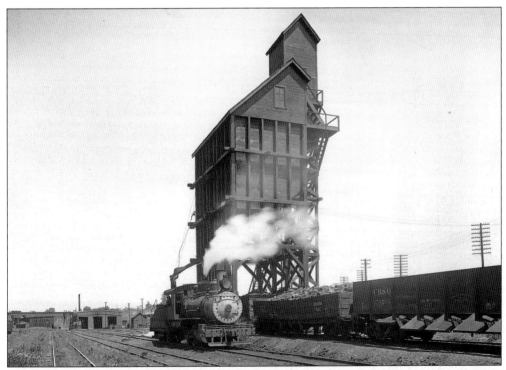

Pictured here is a Baldwin-built Union Stockyards Company 0-6-0 at the chute in the Dahlman Avenue terminal. The enginehouse in the distance has served a local industry since 1954. (Durham Western Heritage Society Collection.)

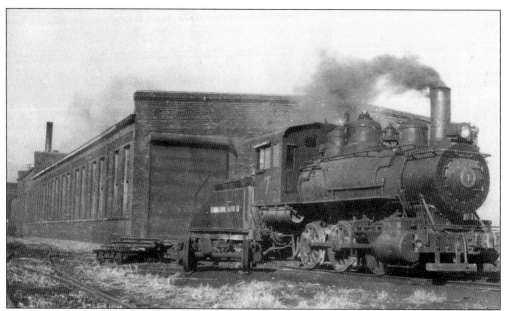

The original roundhouse was located at the south end of the SOT trackage, replaced later by a new enginehouse on Dahlman Avenue. An SOT 0-6-0, one of eleven, simmers between assignments in the yards in 1937. (Henry Hamann photo, Ray Lowry Collection.)

The only road in the area to maintain manure cars and service was the SOT. A load of "s—cars," as they were referred to on the little line, were moved via the UP to Avery, Nebraska where they were unloaded, cleaned, and returned. This photo dates from October 4, 1950.

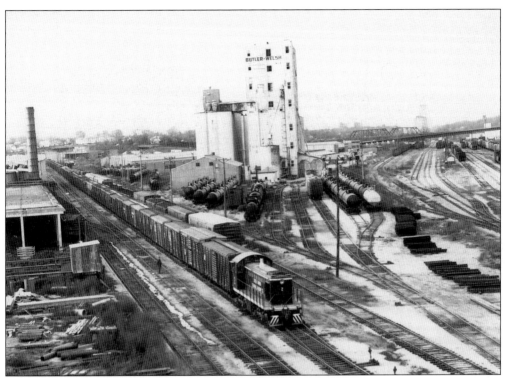

The South Omaha Terminal lived on packing house traffic including the annual fall stock trains off the Burlington, UP, and North Western. On November 11, 1969, the SOT's unique engine, the wartime-built Alco number 2, brings 20 cars of cattle down the hill from the Burlington's South Omaha yard for unloading at the Omaha Stockyards pens.

This picture dates from November 11, 1969. The old pens could handle only 20 car lengths so most trains had to be cut into two or three blocks and spotted and unloaded separately.

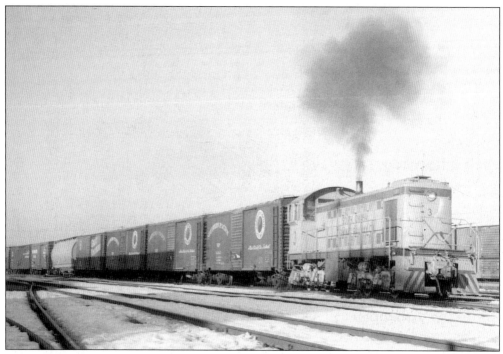

One of the five engine-tired war-time diesels, painted in owner Auto-Liner Corporation's orange colors, switches a grain train to the Union Pacific in 1976. These five Alco S-1s were allowed the railroad under the wartime urgency of keeping meat moving to the troops.

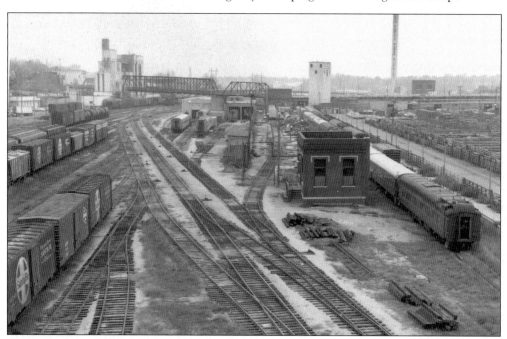

The Auto-Liner Corp. shop complex was adjacent to the stockyards complex. As business grew in the 1970s, new trackage was added along with a new building adjoining the main shop and a new office. This photo is dated 1975.

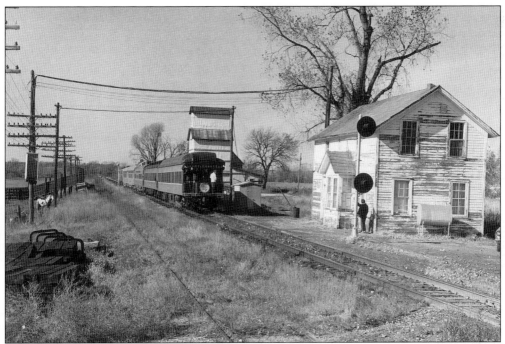

The Auto-Liner operated football special rolls by the Chalco depot on November 6, 1971, headed for Lincoln. (Thomas O. Dutch photo.)

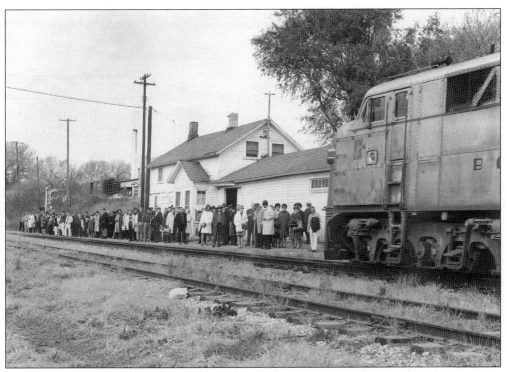

Over half the patrons of the football trains boarded in suburban Ralston as this Missouri game crowd is doing, October 29, 1966. (Thomas O. Dutch photo.)

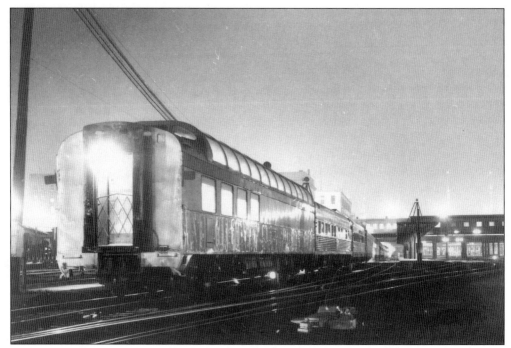

The first westbound Amtrak train pulls into the Burlington Station in the early morning of May 2, 1971. The rear car is an ex-SP dome lounge, later rebuilt by Auto-Liner Corp. in Omaha for Amtrak.

Eastbound Amtrak #6 makes a station stop in July, 1984, just before construction began on a new depot. The first station was a mobile trailer originally provided by Auto-Liner Corp. In the background is the ex-Omaha Union Station.